Jack Chiang's

THOUSAND ISLANDS

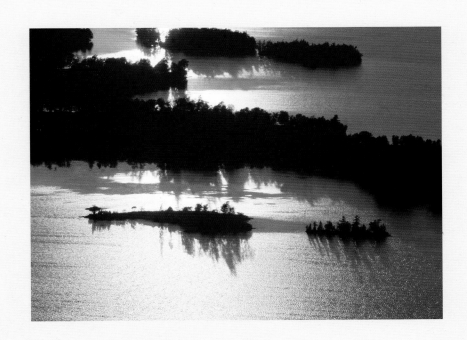

Fitzhenry & Whiteside

Jack Chiang's Thousand Islands
Copyright © 2006 Jack Chiang

Fitzhenry and Whiteside Limited
195 Allstate Parkway
Markham, Ontario L3R 4T8

In the United States:
311 Washington Street,
Brighton, Massachusetts 02135

www.fitzhenry.ca godwit@fitzhenry.ca

Fitzhenry & Whiteside acknowledges with thanks the Canada Council for the Arts, and the Ontario Arts Council for their support of our publishing program. We acknowledge the financial support of the Government of Canada through the Book Publishing Industry Development Program (BPIDP) for our publishing activities.

 Canada Council for the Arts Conseil des Arts du Canada

 ONTARIO ARTS COUNCIL
CONSEIL DES ARTS DE L'ONTARIO

Library and Archives Canada Cataloguing in Publication
Chiang, Jack
Jack Chiang's Thousand Islands / Jack Chiang.

ISBN 1-55041-983-8

1. Thousand Islands Region (N.Y. and Ont.)—Pictorial works.
I. Title. II. Title: Thousand Islands.

FC3095.T43C44 2006 971.3'7'00222 C2005-907744-1

United States Cataloguing-in-Publication Data

Chiang, Jack.
Jack Chiang's Thousand Islands / Jack Chiang.
[128] p. : col. photos. ; cm.
Summary: A photographic journey through the Thousand Islands region of North America.
ISBN 1-55041-983-8
1. Thousand Islands (N.Y. and Ont.) — Pictorial works. I. Thousand Islands. I. Title.
974.758 dc22 F127.T5C55 2006
Cover and interior design by Darrell McCalla
1 3 5 7 9 10 8 6 4 2

Printed in Hong Kong

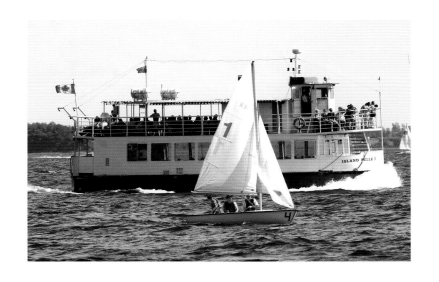

THIS BOOK
IS DEDICATED TO
BERNICE AND KEITH WATSON
PETER AND FRANCES SPLINTER
AND DR. JIM BELIVEAU

Introduction

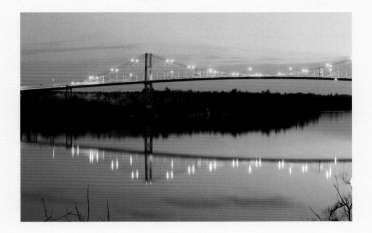

I CAME TO THE THOUSAND ISLANDS REGION ALMOST 30 YEARS AGO because I needed a job; I stayed because I've been captivated by its beauty. The Thousand Islands is truly a photographer's delight.

It is not surprising that since the 1870s the Thousand Islands has been a vacationland for the rich and famous. In the early days, North America's most affluent came by steamboat and by train, often with servants in tow. They stayed in luxurious hotels. Some even built their own luxurious "cottages" to match.

Today, though, the Thousand Islands is accessible – and affordable – to almost everyone. That's why, every year, hundreds of thousands of tourists from around the world come for a visit. They arrive by tour bus and by car, van and truck. And they usually take a boat cruise, at Kingston, Gananoque, Rockport, Brockville, Clayton or Alexandria Bay. It's here, out among the islands, that they can learn about the tragic love story behind the Boldt Castle. They can cruise by "Millionaires' Row" near Alexandria Bay and weave across parts of the longest undefended border in the world.

They can discover place names that conjure up the region's colourful past: Smugglers' Cove, Lost Channel, Deadman Bay, Fiddlers' Elbow, Wanderers' Channel, and Treasure Island.

And they can learn that the "Thousand Islands" is in fact a misnomer: there are actually between 1,200 and 1,800 islands, with the total number of "islands" changing as fluctuating water levels expose and submerge many of them.

It is amazing what one can discover during a three-hour cruise. However, it takes more than a boat cruise to appreciate the Thousand Islands. This area is steeped in history. The Algonquin and Iroquois lived here centuries before the well-to-do came on vacation. And in 1673, Count Frontenac, the recently appointed Governor of New France, visited this region and recognized its importance. The trading post he subsequently built, at Cataraqui, was the beginning of Kingston, the first capital of Canada.

Like much of this part of North America, the Thousand Islands region was shaped by the forces of ice that once lay up to three kilometres thick. The present landscape began to take shape when these glaciers started to melt and retreat about 12,000 years ago.

While the shape of the land has remained relatively constant ever since, the scenery has not. You can go to the same place at different times and see different things. Every time I drive along the Thousand Islands Parkway, on the Canadian side, I'm amazed by the different scenery I see.

So come, take a journey through the Thousand Islands with me. You'll be amazed!

Jack Chiang

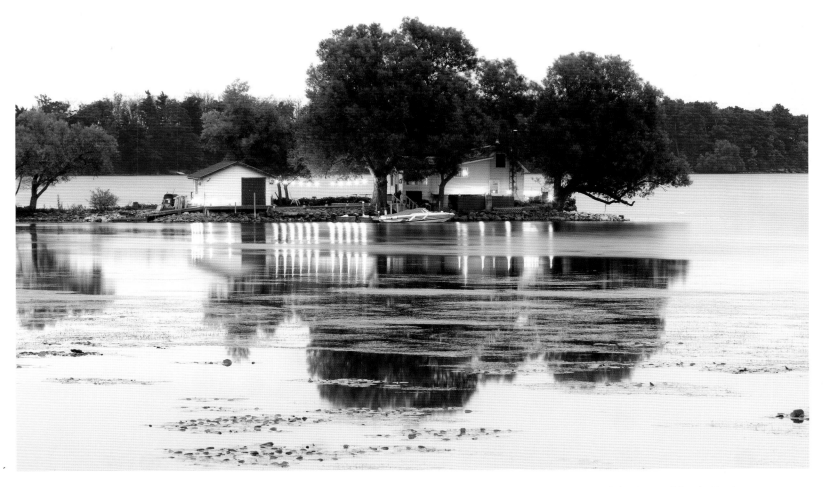

This cottage east of Gananoque is one of the Sisters Islands. In the background is Gordon Island of St. Lawrence Islands National Park.

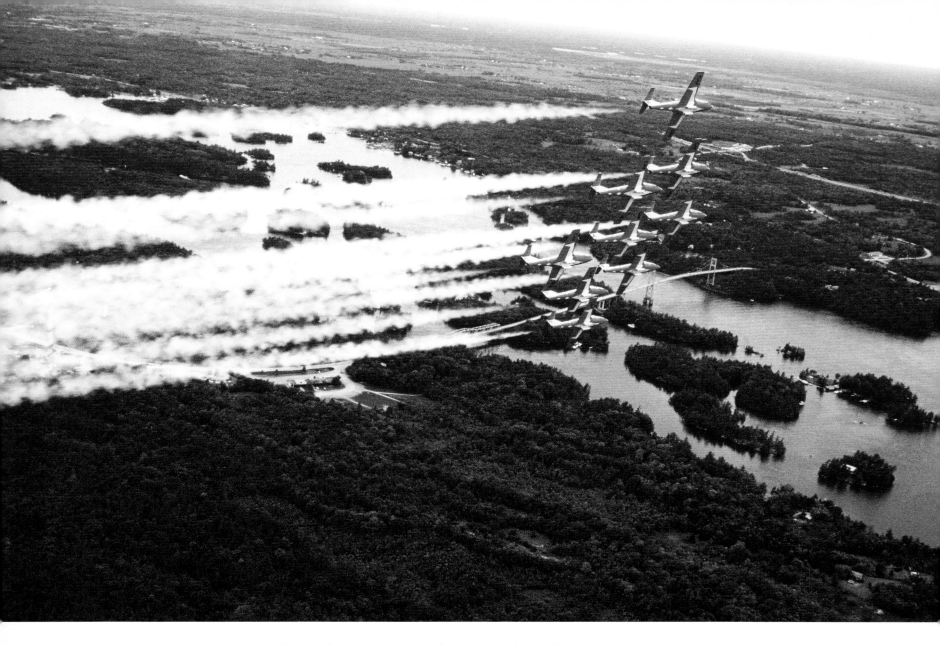

Canada's Snowbirds aerobatic team flies over the Thousand Islands International Bridge
that connects Canada and the United States.

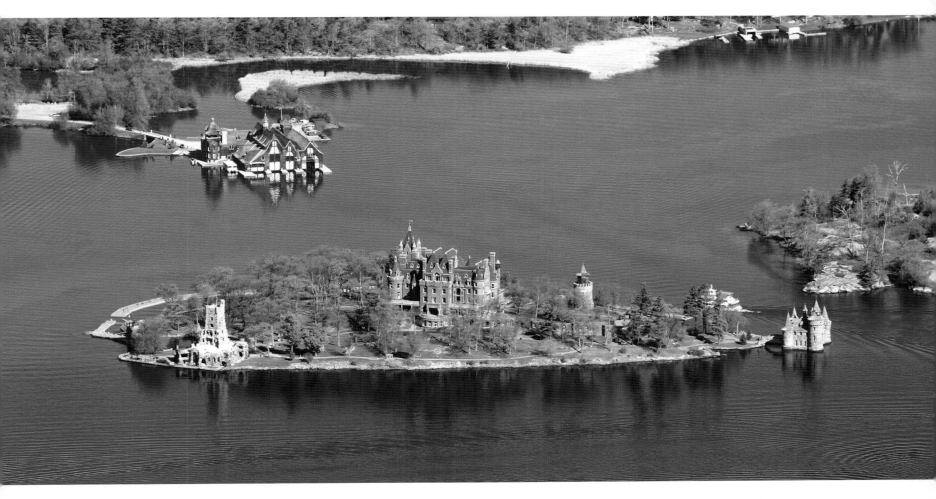

Hotelier George Boldt bought Heart Island near Alexandria Bay and began building a castle as a show of love for his wife, Louise. Work began in 1900. Louise died in 1904 and the heartbroken George Boldt ordered a halt to construction.

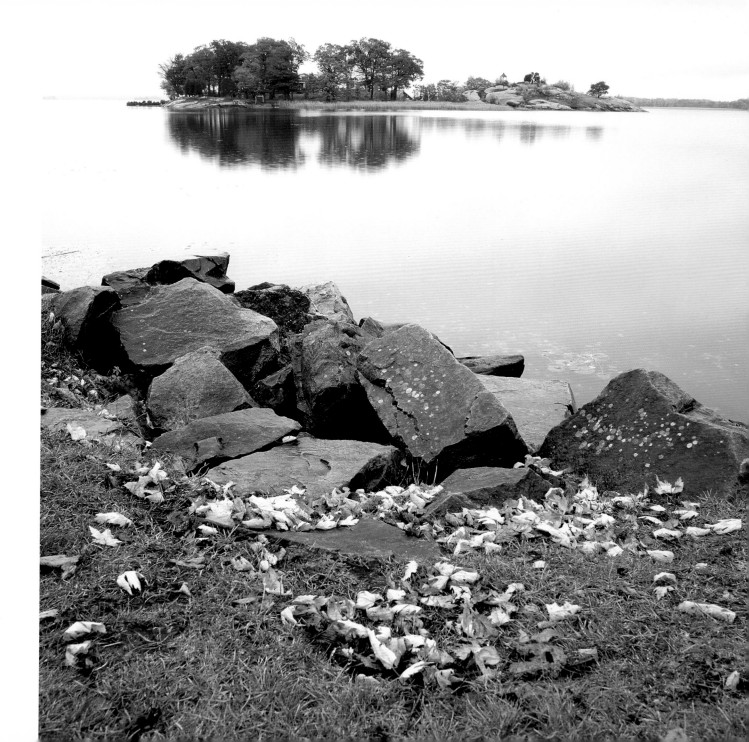

Fall colours or studio
tours are popular in
the Thousand Islands.

4

Wind-swept trees and cottages on stilts are among
the many unusual sights in the region.

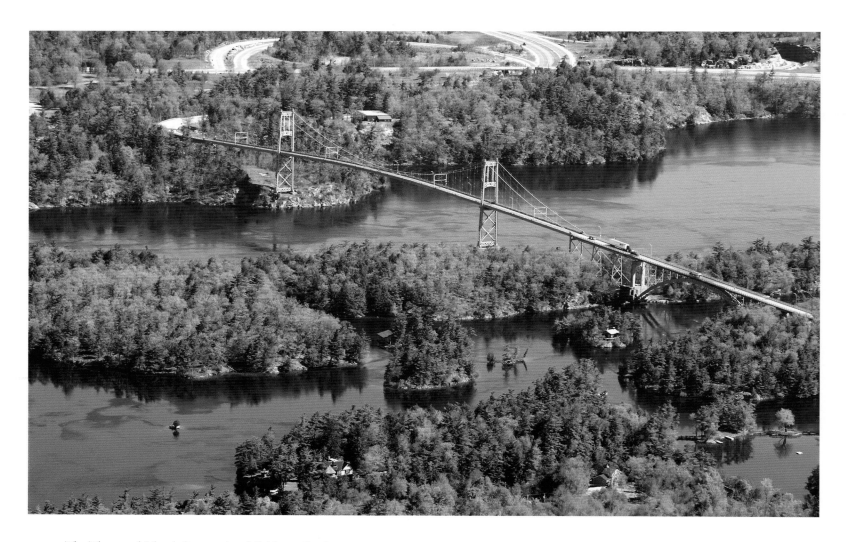

The Thousand Islands International Bridge at Ivy Lea
was officially opened by President Franklin D. Roosevelt
and Prime Minister Mackenzie King in August, 1938.

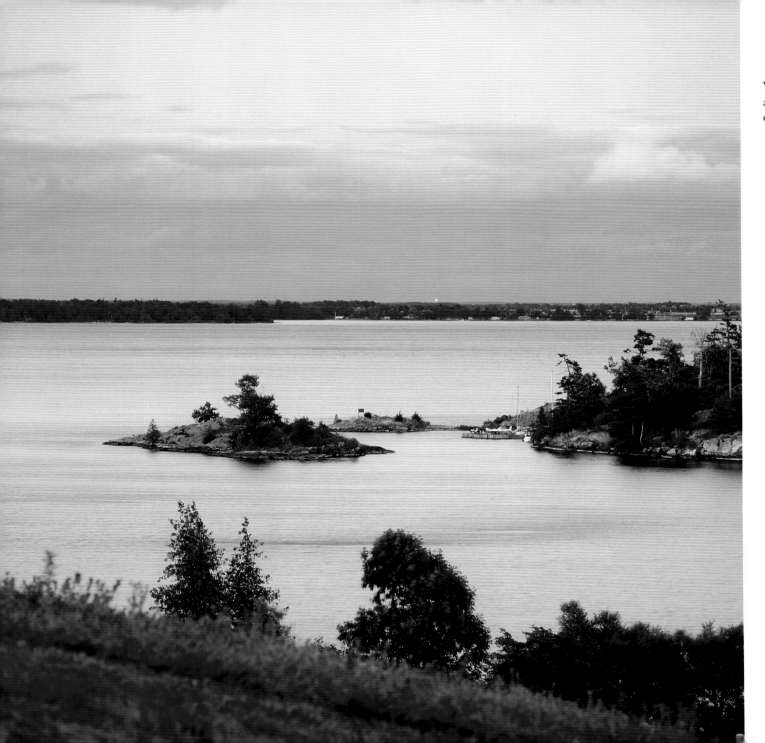

Whiskey Island is located at Deadman Bay just south of Fort Henry.

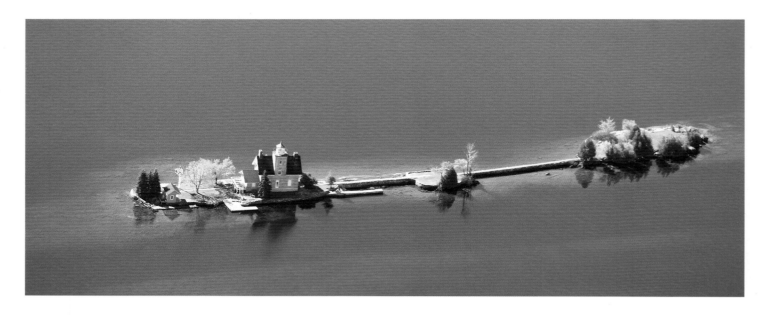

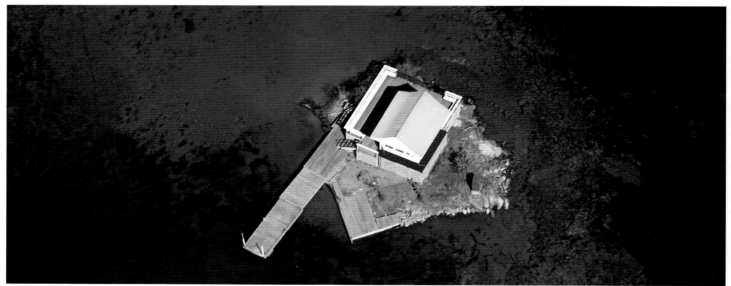

Islands come in all shapes and sizes. Sister Island, above,
is one of the most unusual.

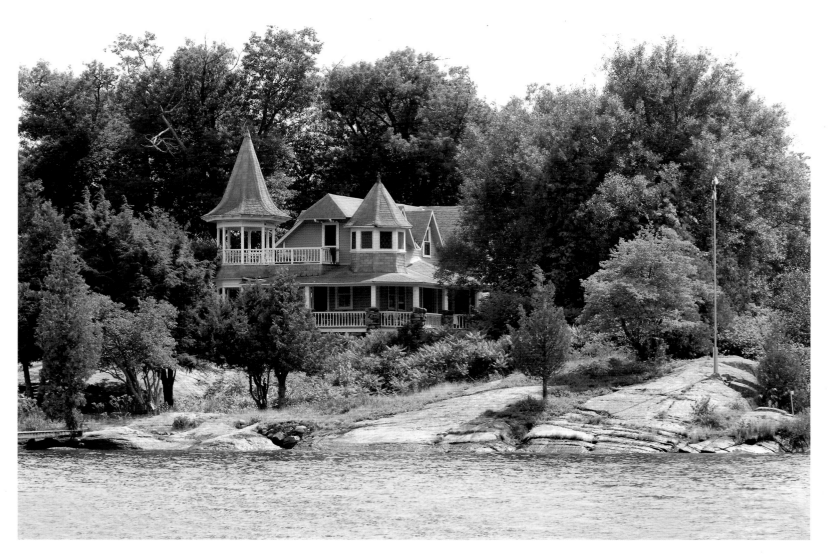

This island on Wanderers' Channel belongs to the
Innes family. The island is known locally as The Towers.

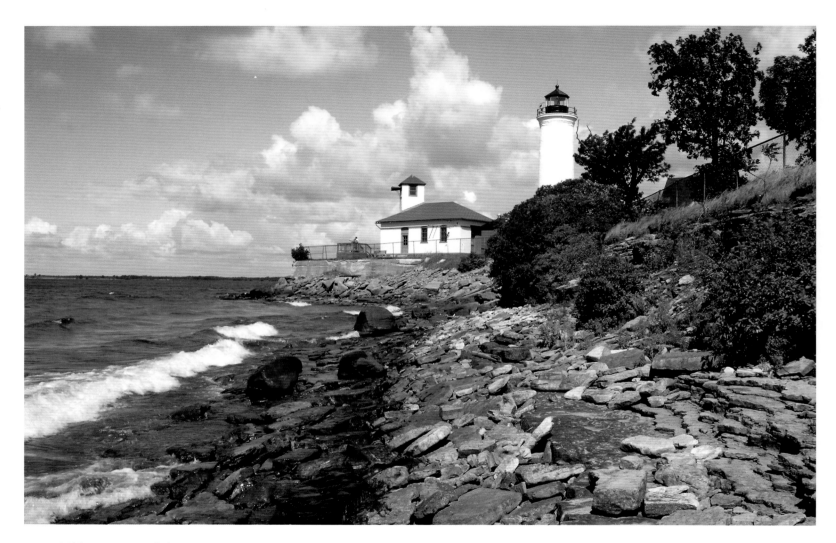

Tibbetts Point Lighthouse, in existence since
1827, is one of Cape Vincent's major landmarks.

Right: Photogenic Miller Island is located
two kilometres west of Mallorytown Landing.
The small island at right is Channel Island,
with Grenadier Island at the back.

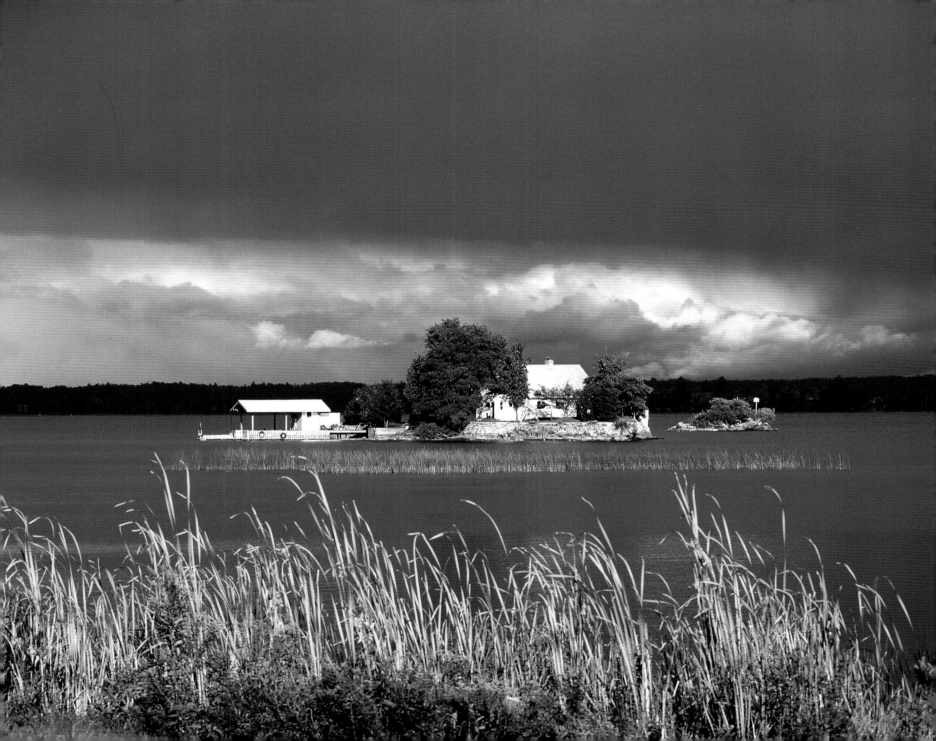

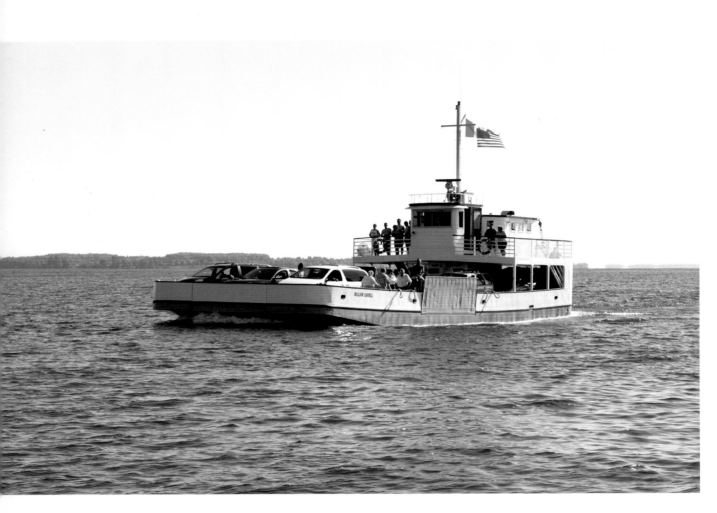

Horne's Ferry, which runs between Wolfe Island, Ontario, and Cape Vincent, New York, is one of the shortest international crossings.

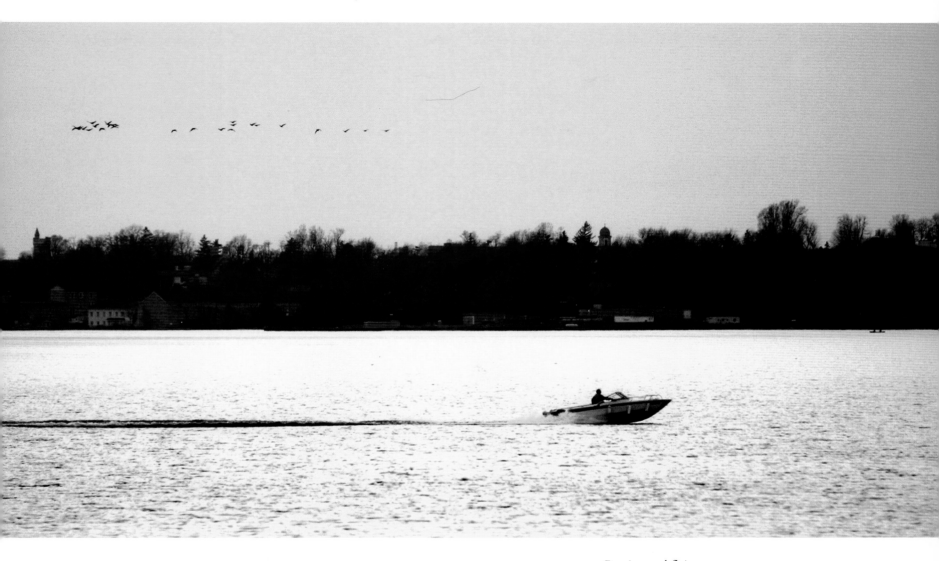

Boating and flying are common means
of transportation between Wolfe Island
and Kingston.

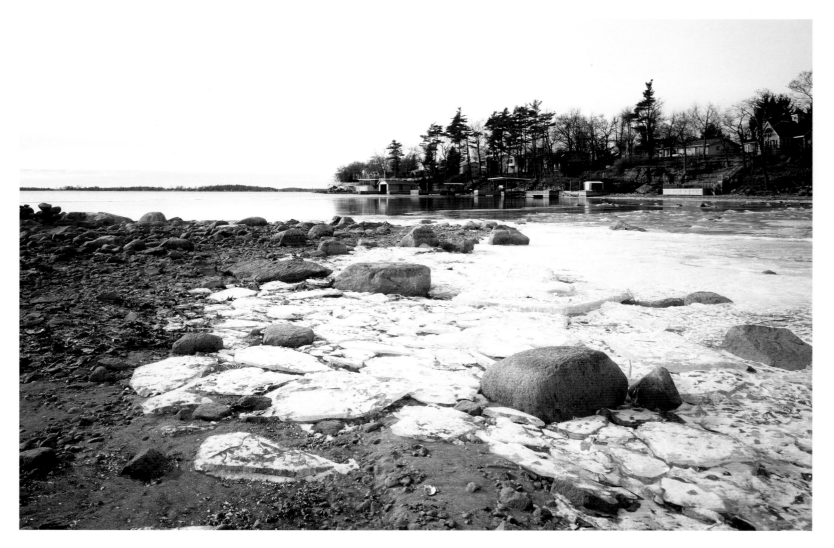

Ancient rocks like these can be seen when the water level
is low. The landscape of the Thousand Islands was created by
glaciers which receded about 12,000 years ago.

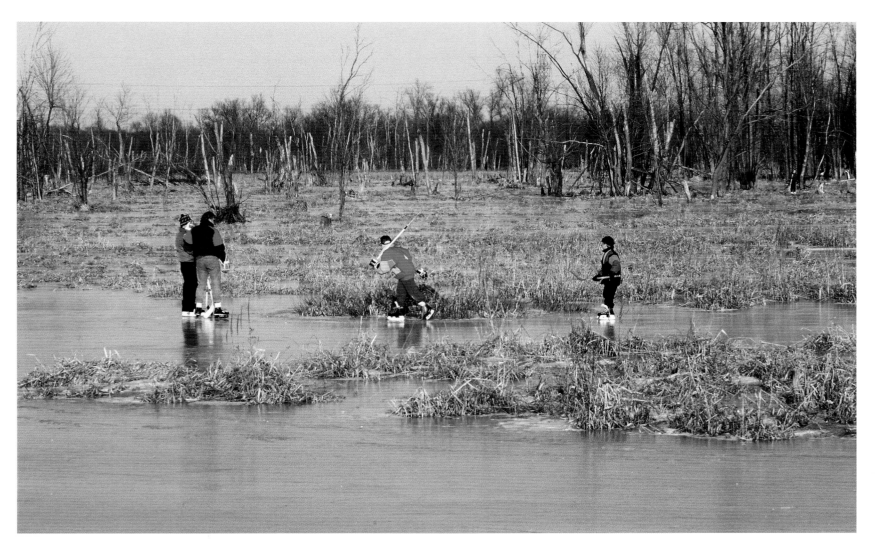

When there is a will, there is a hockey pond for these youngsters at Collins Creek in Kingston.

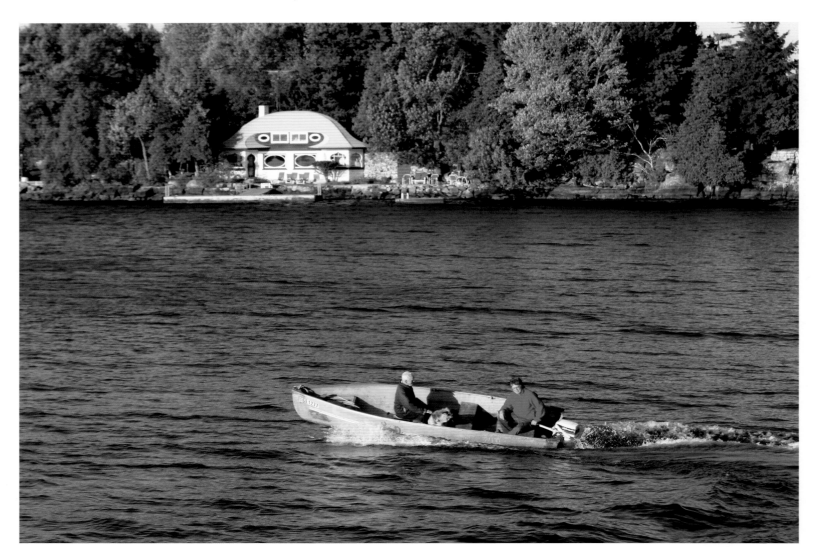

Mark Russell takes his dad Robert out for a
ride. The striking cottage in the background is
owned by Phil and Merle Koven of Kingston.

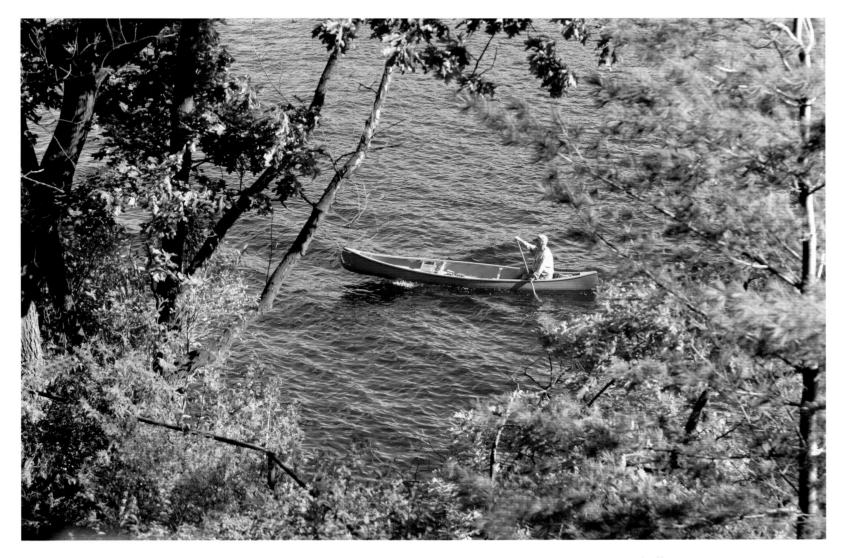

A canoeist enjoys some peace and quiet near Merv and Nancy Earl's property in Brockville.

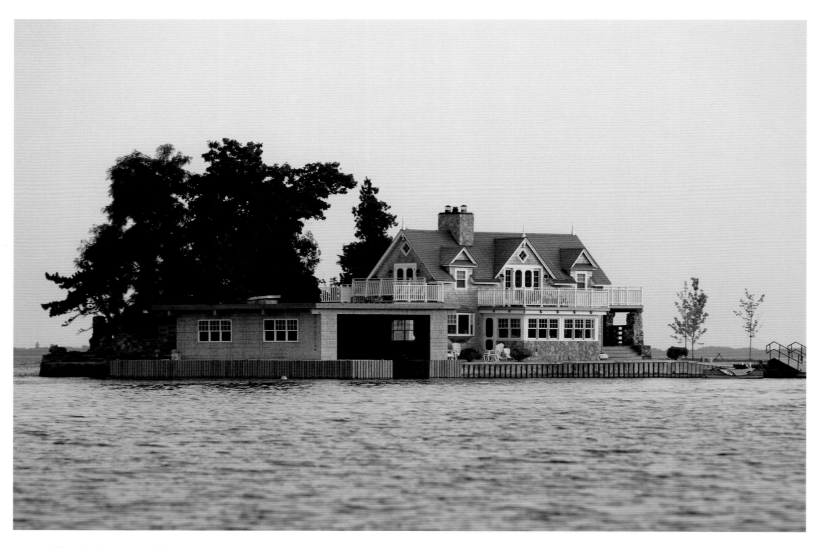

The "parking garage" at this residence near
Gananoque is a boathouse.

Right: It is easy to get away from it all
along the Thousand Islands Parkway.

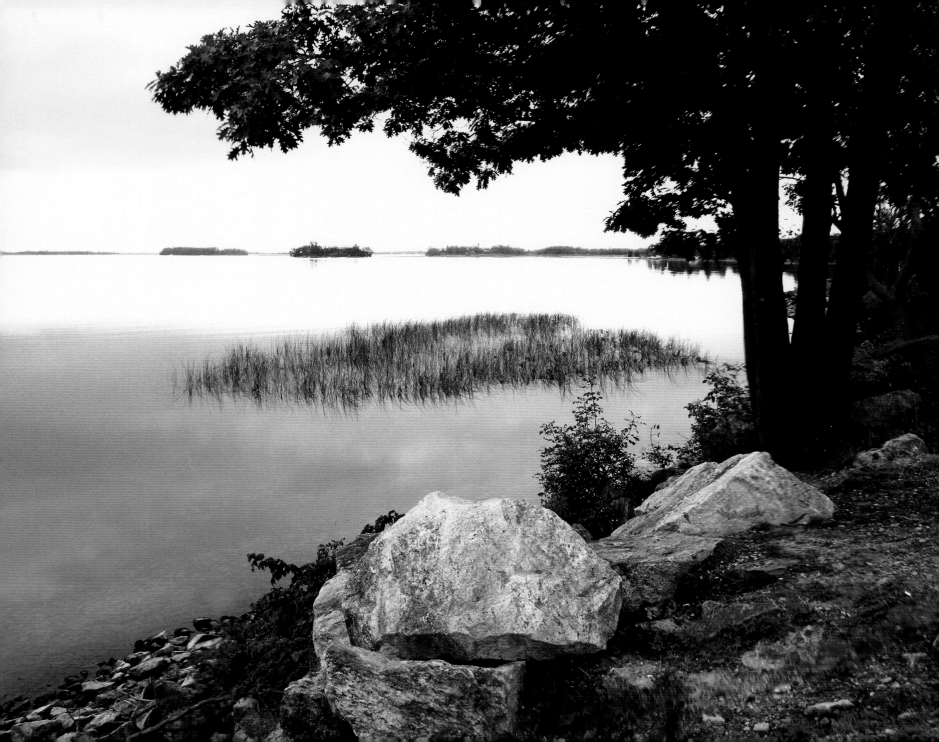

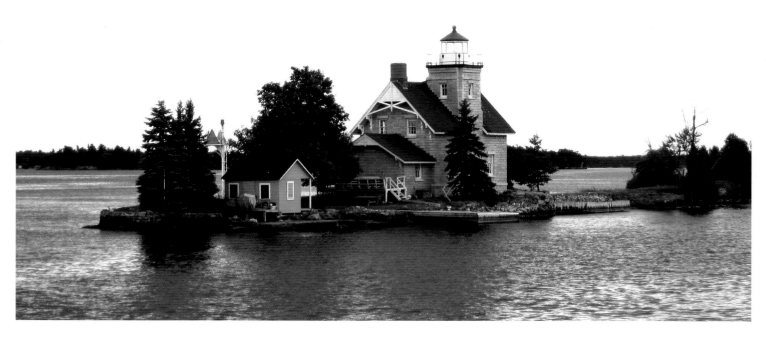

Sister Island, once a lighthouse, used to consist
of three small islands which are now all connected.

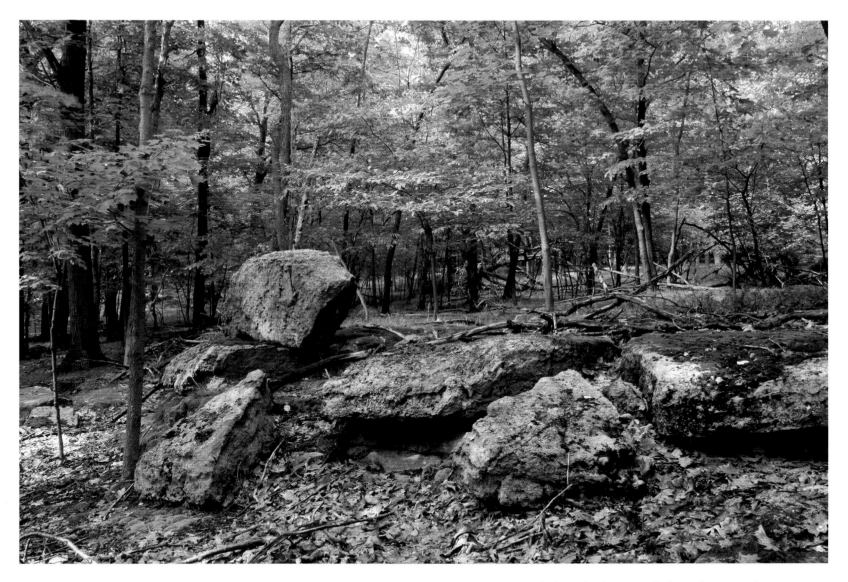

Wellesley Island State Park, located minutes from
Alexandria Bay, is an excellent place for fishing,
boating, camping, cross-country skiing and hiking.

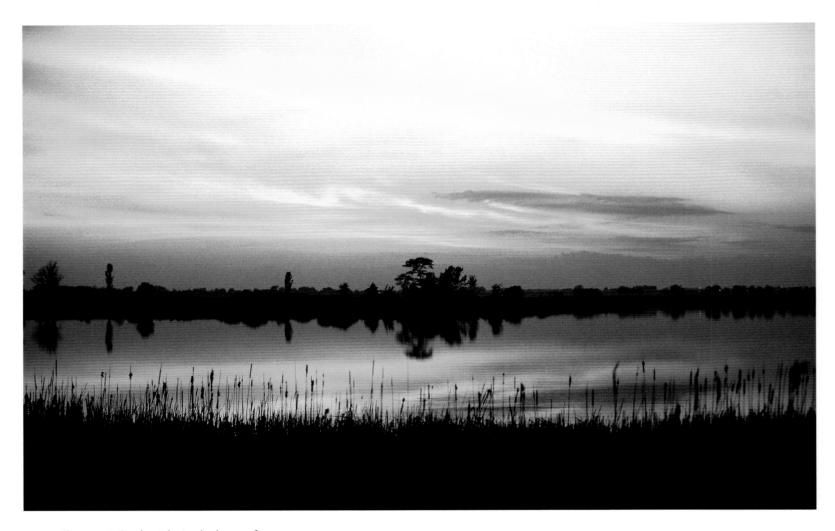

Cataraqui Creek, right in the heart of
Kingston, is part of the Cataraqui Bay
Marshlands Conservation Area.

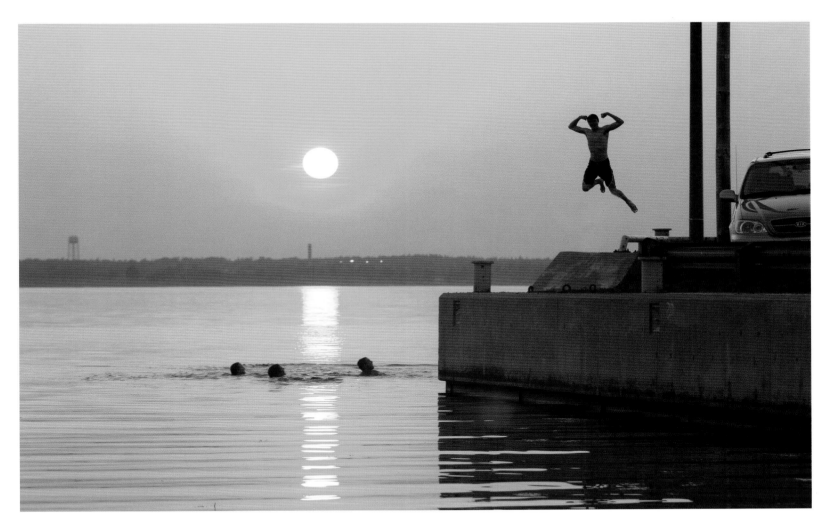

These youngsters on Amherst Island know
how to enjoy the summer.

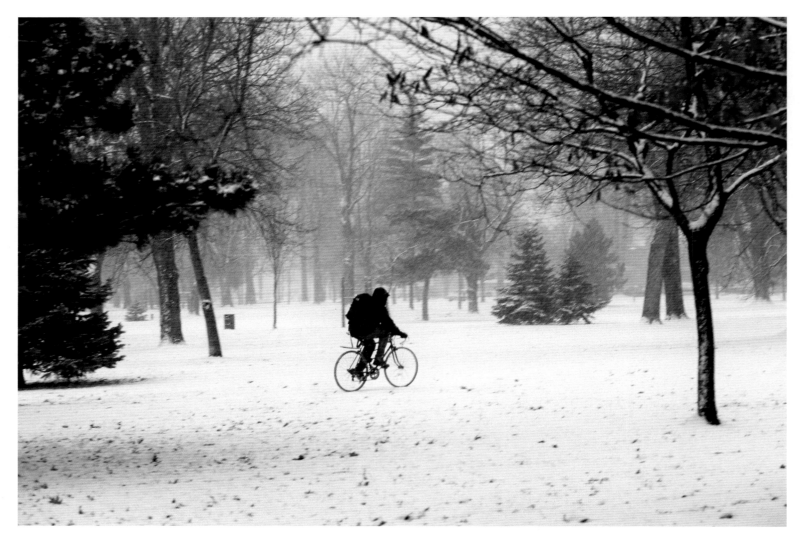

Heavy snow doesn't stop this student from
cycling through Kingston's City Park.

Right: Lovely Westport, north of
Kingston, is picture perfect after
a snowfall.

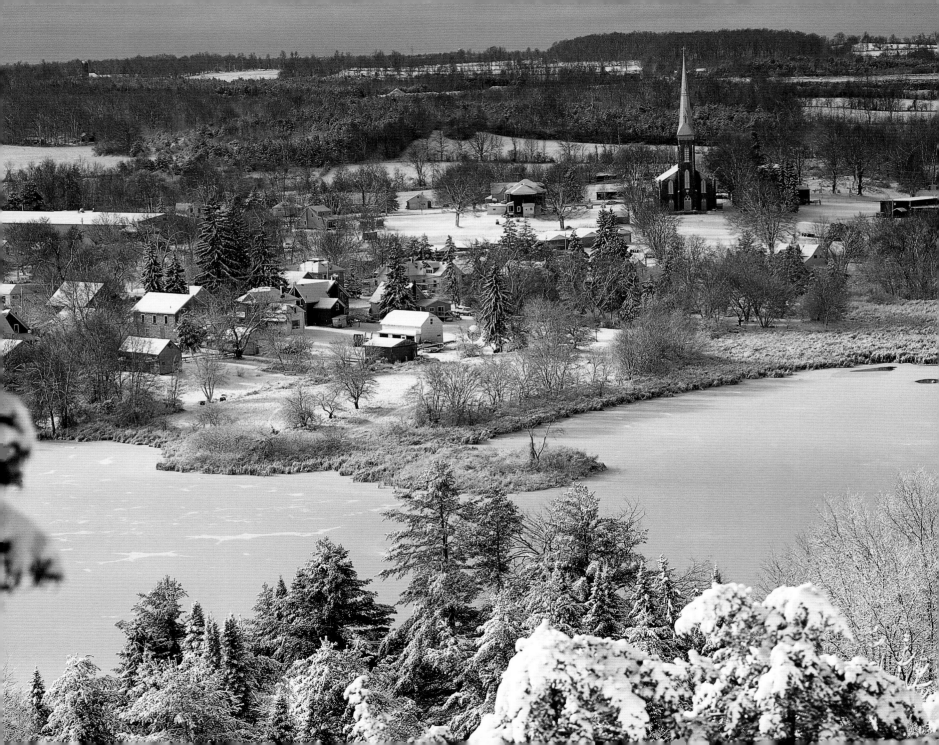

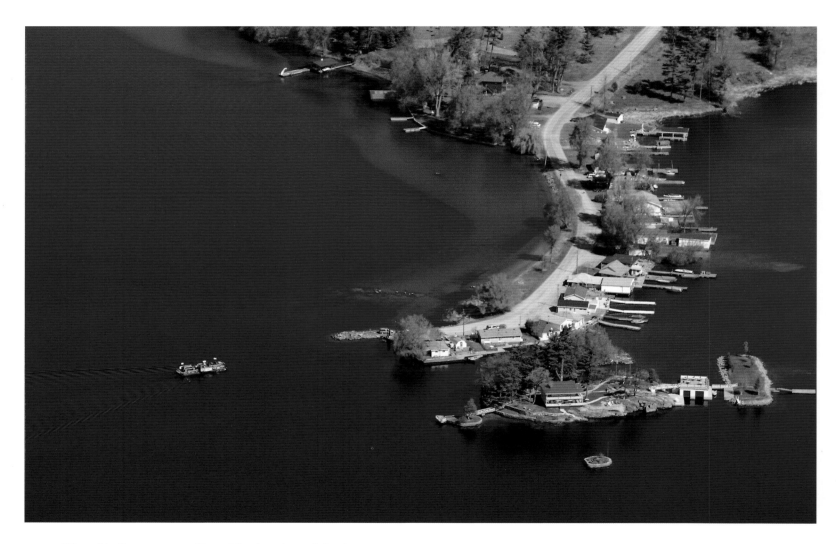

The cable-ferry connects Howe Island to the mainland.

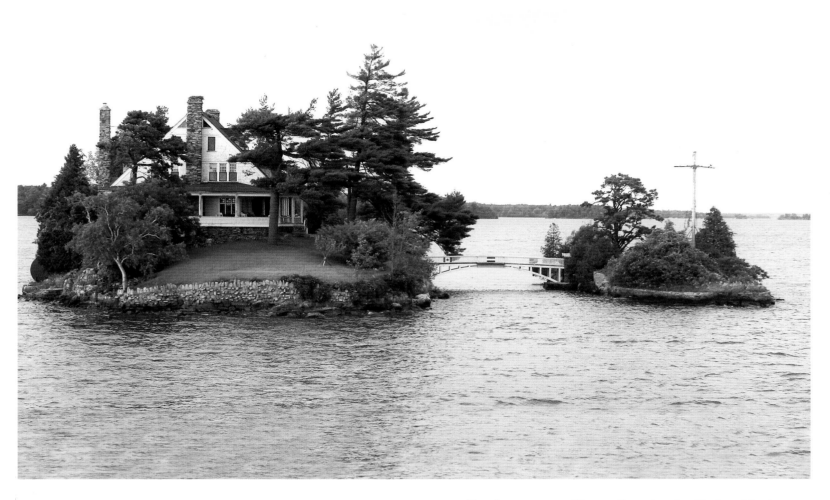

Tour-boat operators like to tell tourists that Zavikon Island, left, and Island #103A are connected by the world's shortest international bridge. In reality, both islands are in Canada.

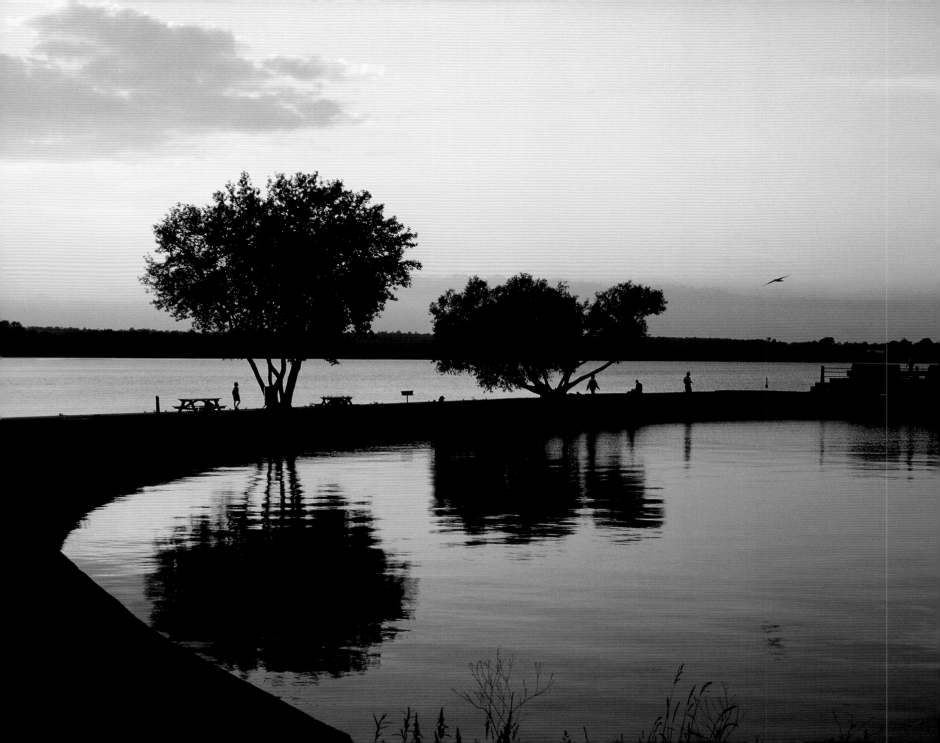

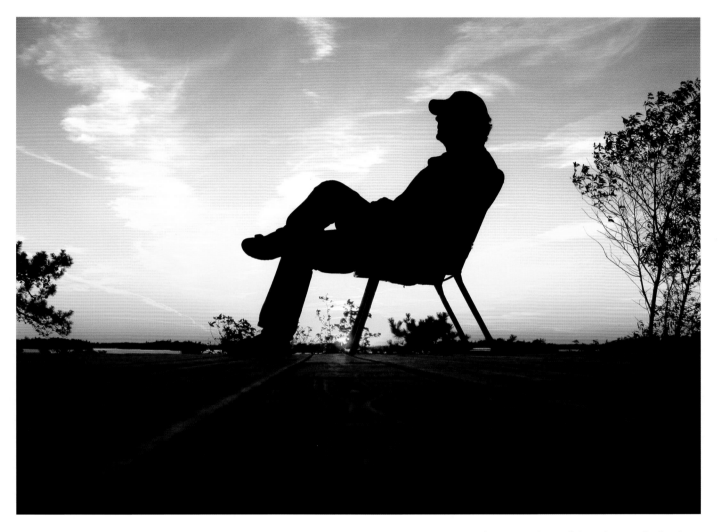

Paul Tierney, a lifelong resident of the Thousand Islands, enjoys a glorious sunset.

Left: Scenic Kingston Mills is one of the lock stations of Rideau Canal, which connects Kingston and Ottawa.

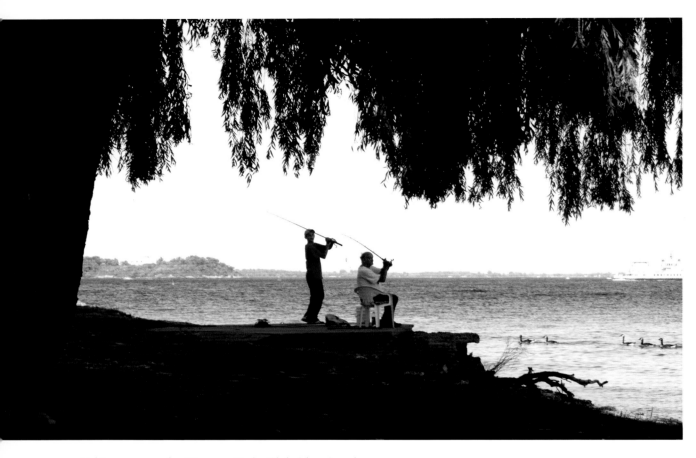

Fishing — near the Kingston Yacht Club (above) and on
the Cataraqui River (at right) — is a popular pastime.

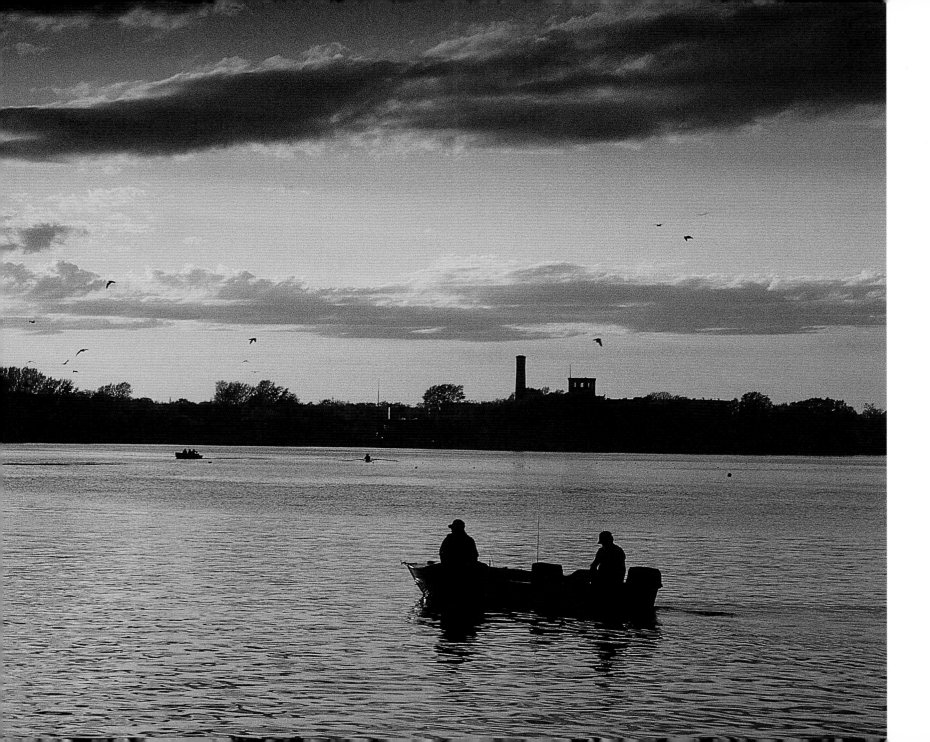

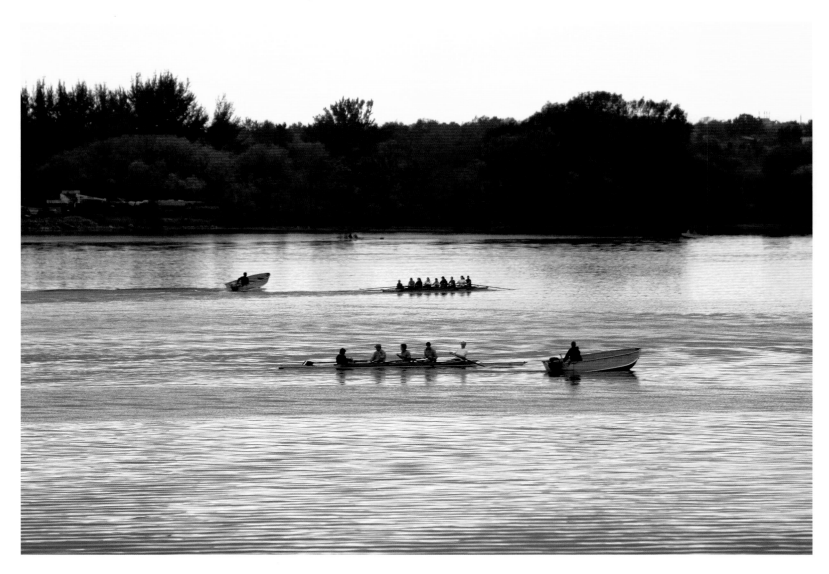

Members of the Kingston Rowing Club
practice on the Cataraqui River.

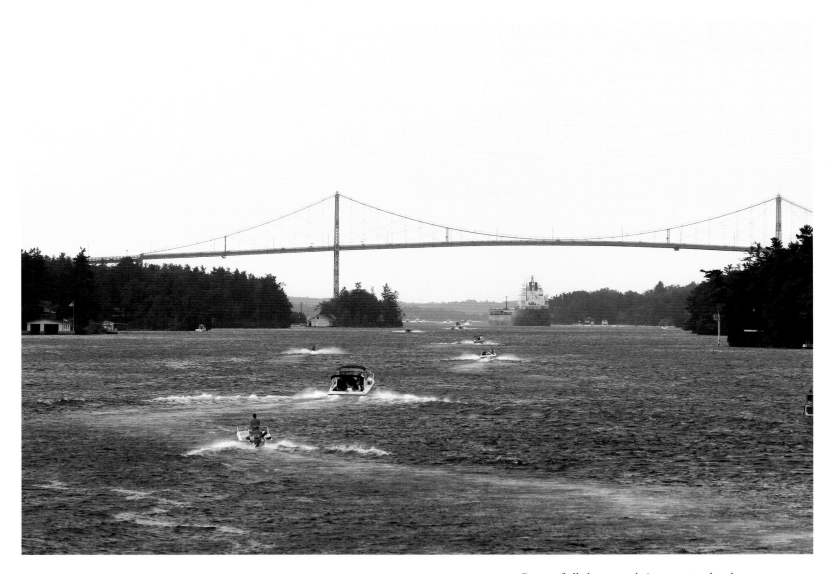

Boats of all shapes and sizes pass under the
Thousand Islands International Bridge at Ivy Lea.

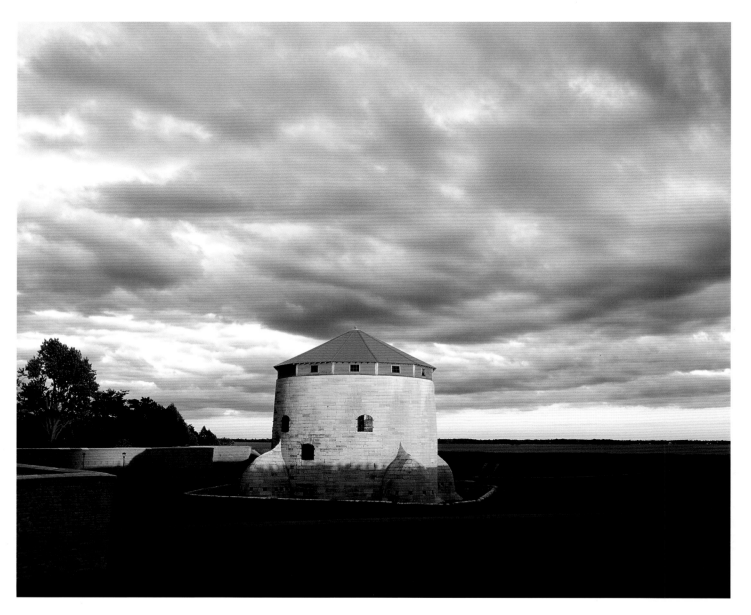

Point Frederick Tower is one of Kingston's four Martello Towers –
a style of defence fortification – built to protect the city
after the War of 1812.

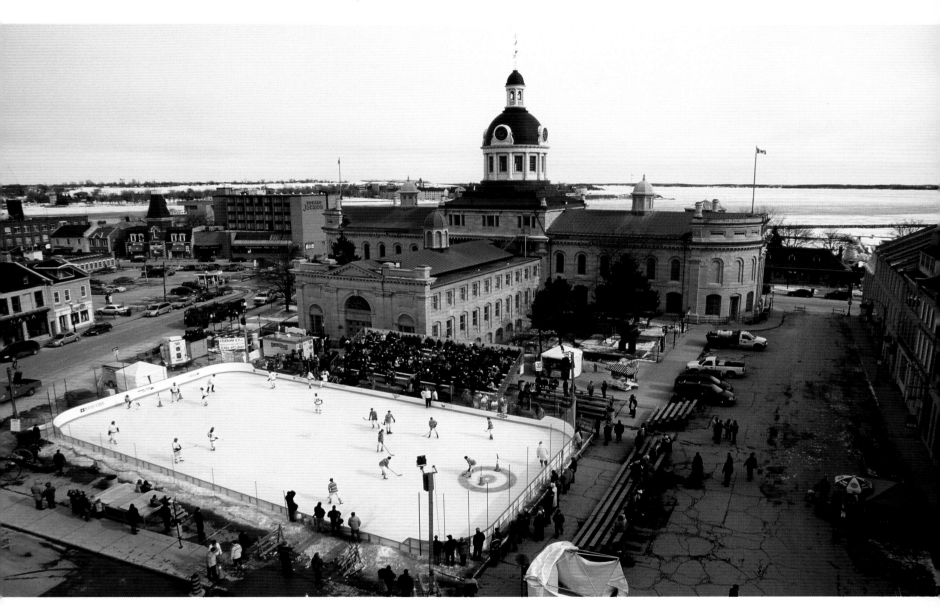

A historic hockey series that featured Queen's University, Royal Military College, and the Royal Canadian
Horse Artillery is replayed at Kingston's venerable farmer's market behind City Hall.

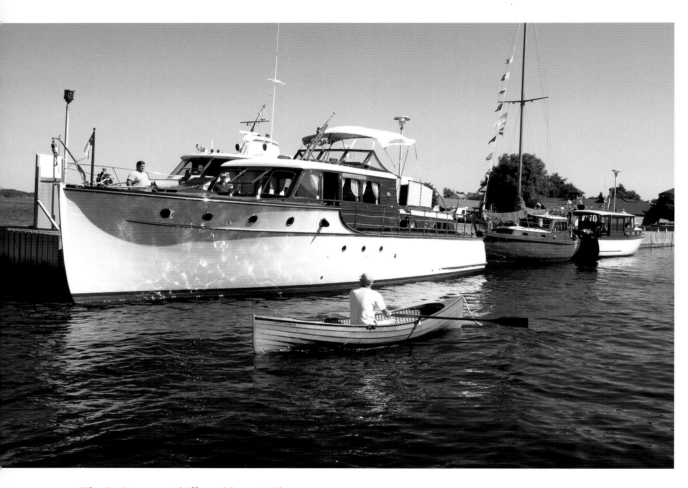

The St. Lawrence skiff, used here in Clayton, is a unique rowboat that has been used in the Thousand Islands since the 1840s.

Right: Sunday service has been held since 1887 at Half Moon Bay on Bostwick Island near Gananoque.

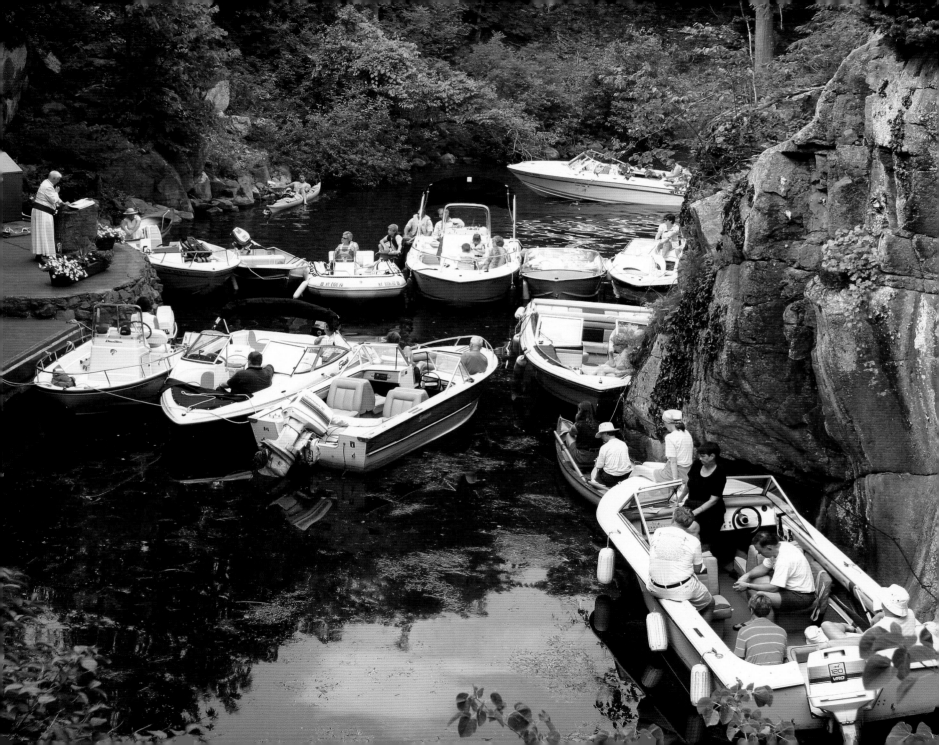

St. Brendan's Catholic Church is
the major landmark in the quaint
village of Rockport.

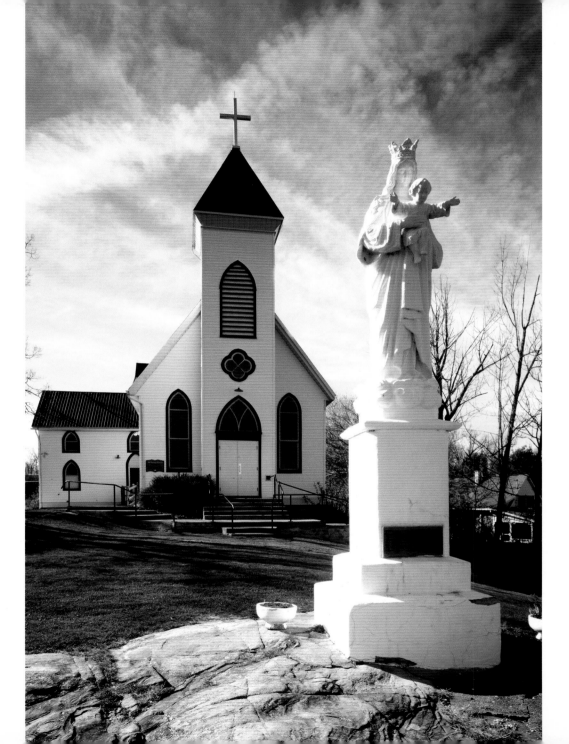

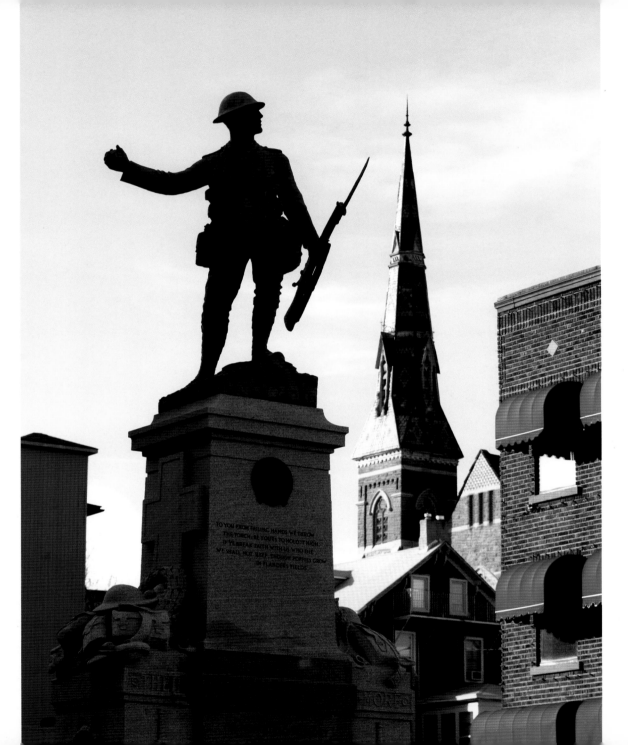

The war memorial stands guard in downtown Brockville, the second-largest city in the Thousand Islands.

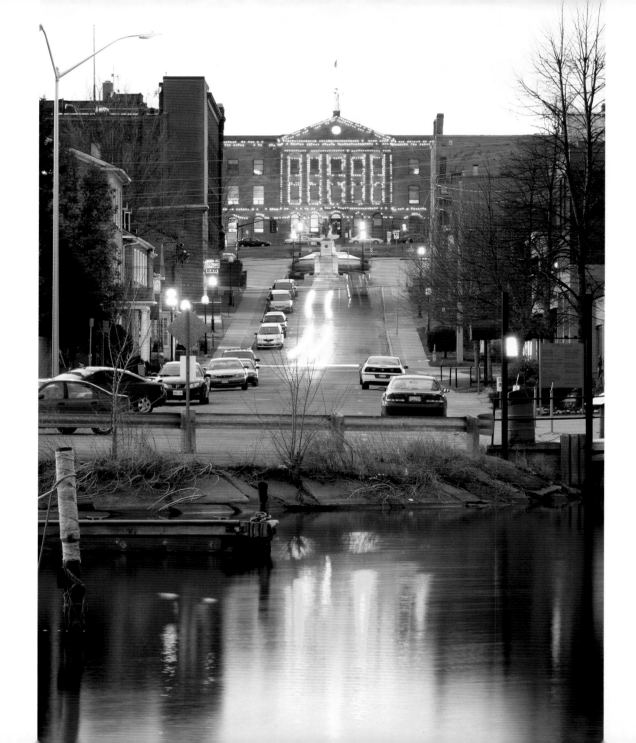

Brockville's hilltop courthouse
dominates the city landscape.

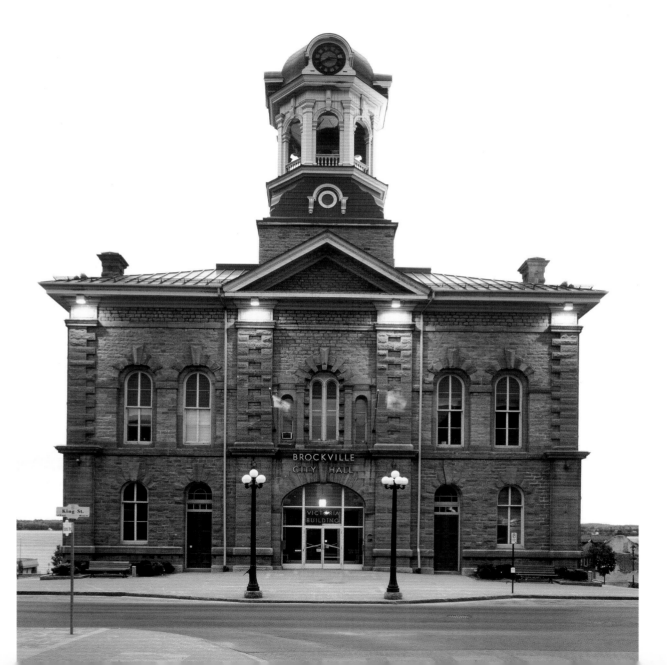

Historic Victoria Hall is the home of the City Hall of Brockville, the first incorporated municipality in Ontario. United Empire Loyalists first settled in the area in 1785. In 1812, the town's name was changed from Buell's Bay to Brockville, after Major-General Sir Isaac Brock, the hero of the War of 1812.

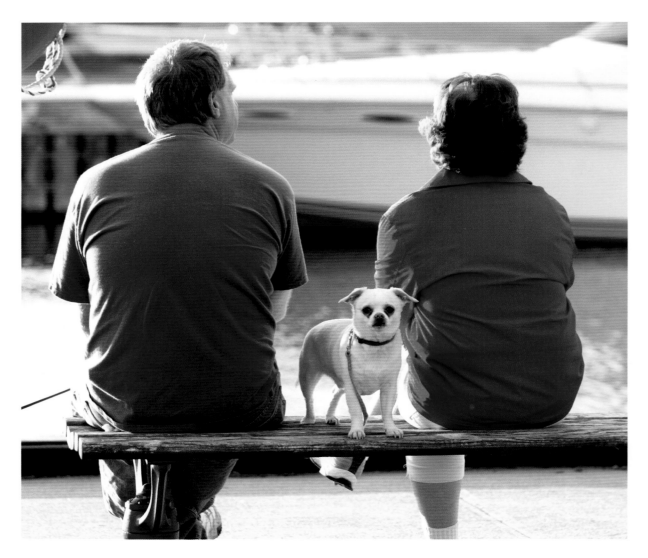

A couple and their dog watch the world go by at Brockville's waterfront.

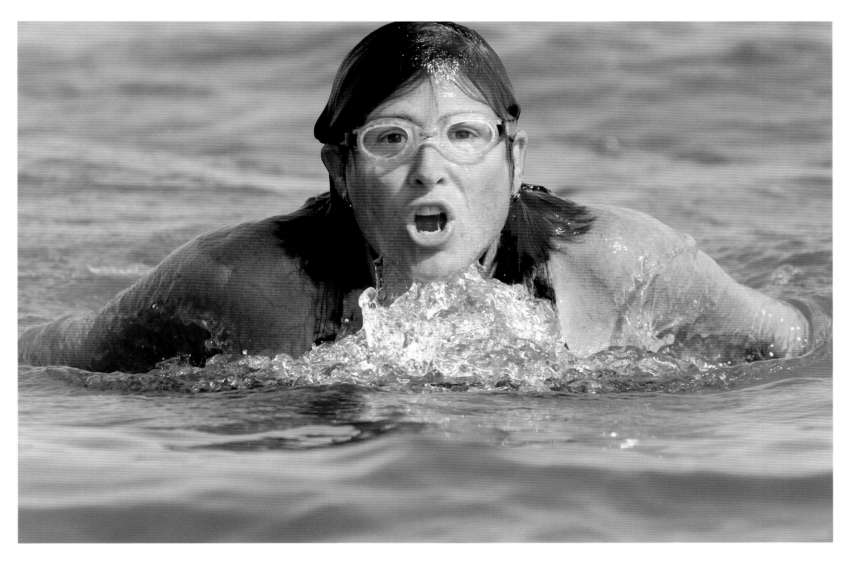

Marathon swimmer Vicki Keith, a resident of Amherst Island,
holds 14 world marathon swim records.

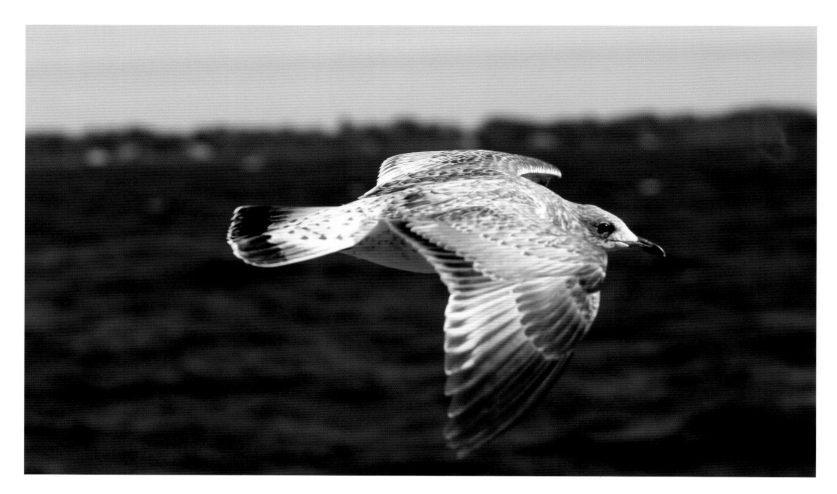

The ubiquitous gull never stops its search for food.

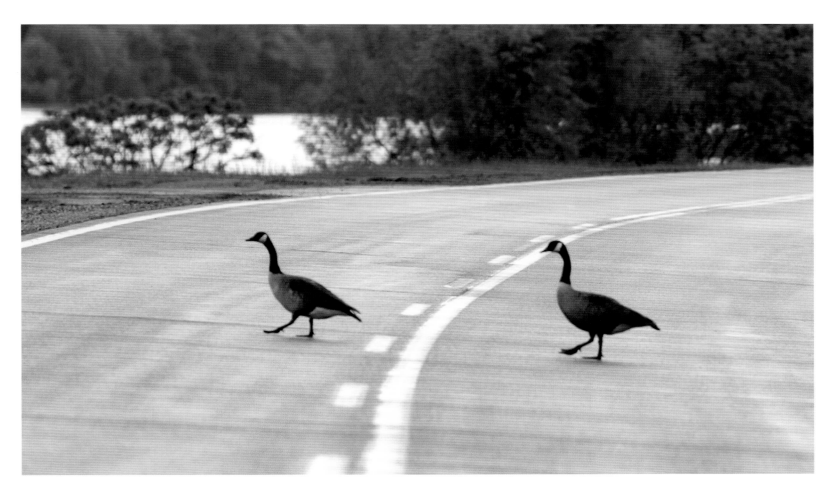

Why do these geese cross the Thousand Islands Parkway?

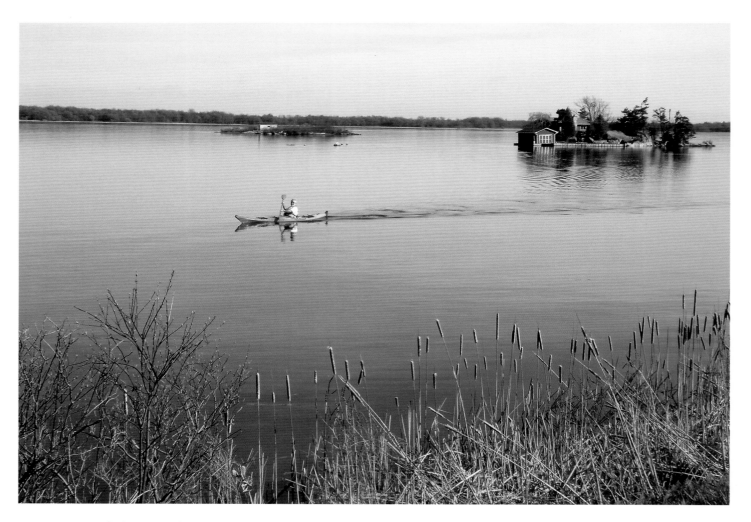

It is easy to find peace and quiet in the Thousand Islands,
which stretches more than 50 miles (80 kilometres).

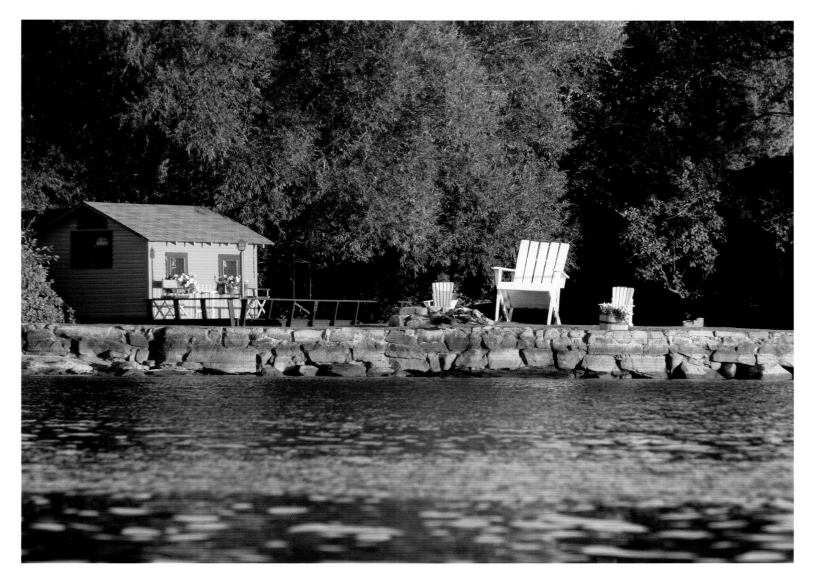

For more than a century, the Thousand Islands region has been a favourite vacationland for people on both sides of the border. Today, many people spend whole summers relaxing in their cottages.

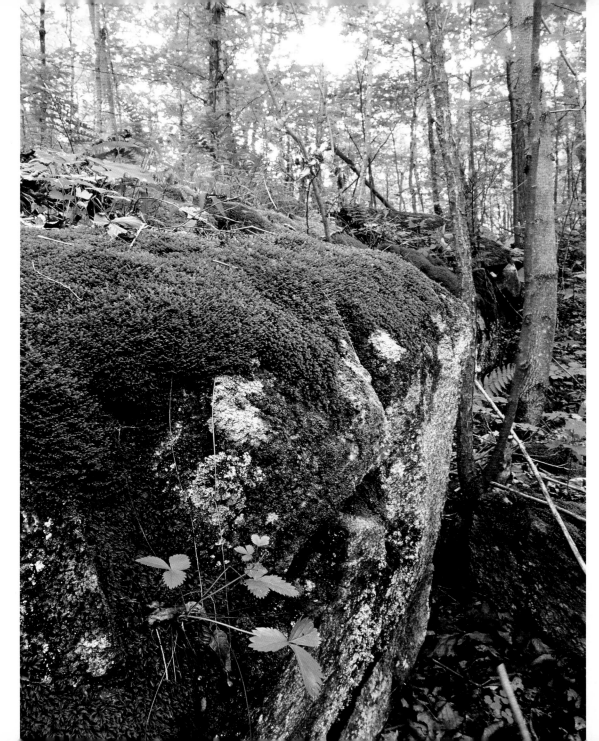

Frontenac Provincial
Park north of Kingston
looks good whether it
is in the spring (right)
or in the fall (far right).

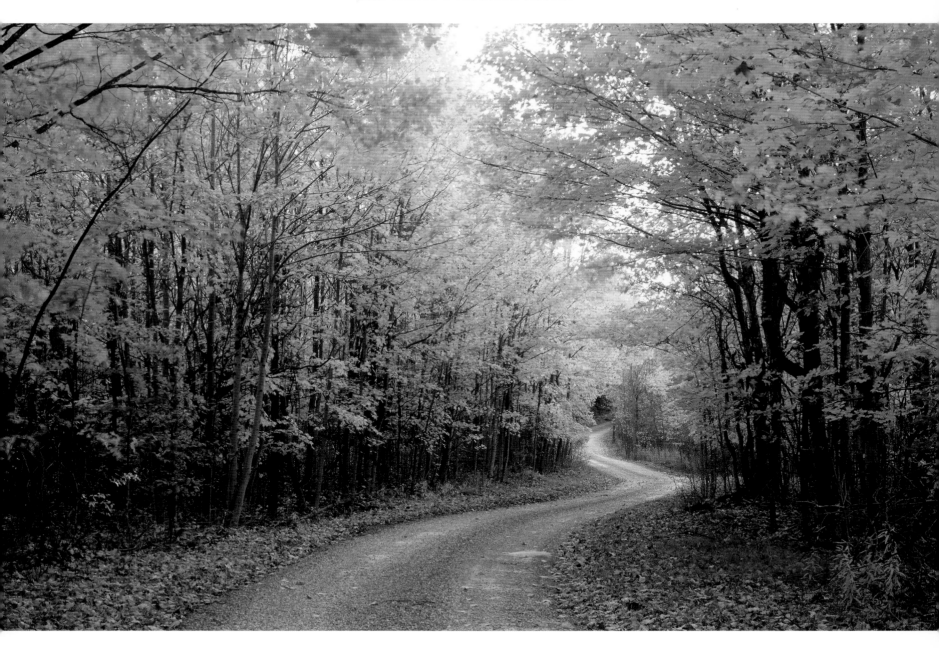

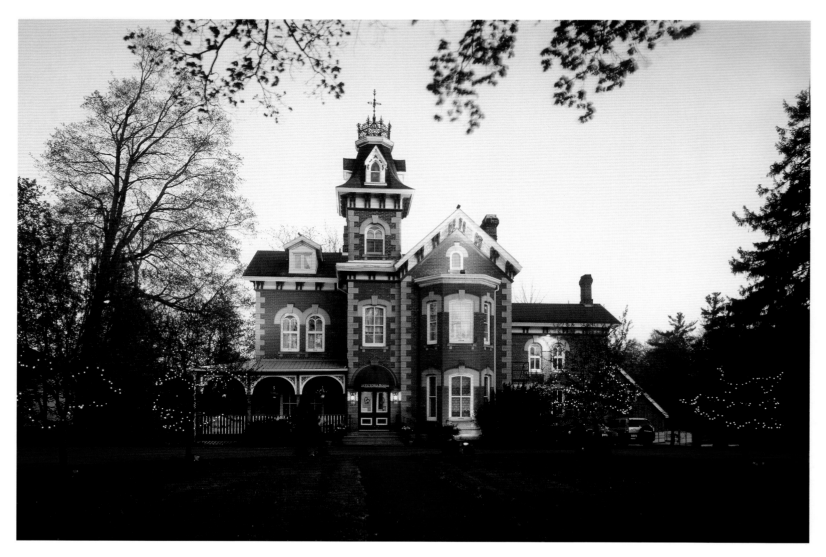

Gananoque's Victoria Rose Inn, built in 1872, is one of
the region's many elegant, well-kept mansions.

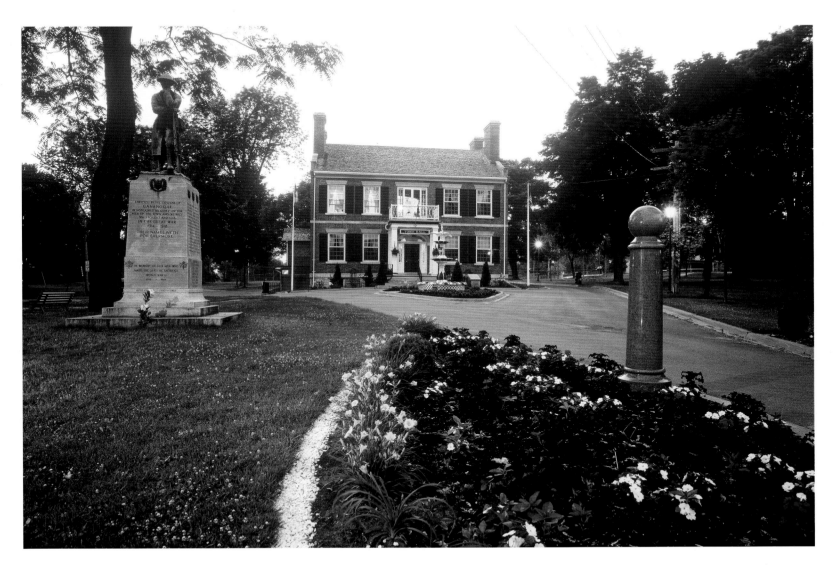

Gananoque's Town Hall, built around 1832, was once the home of Henrietta and John McDonald. In 1911, the family deeded it to the town.

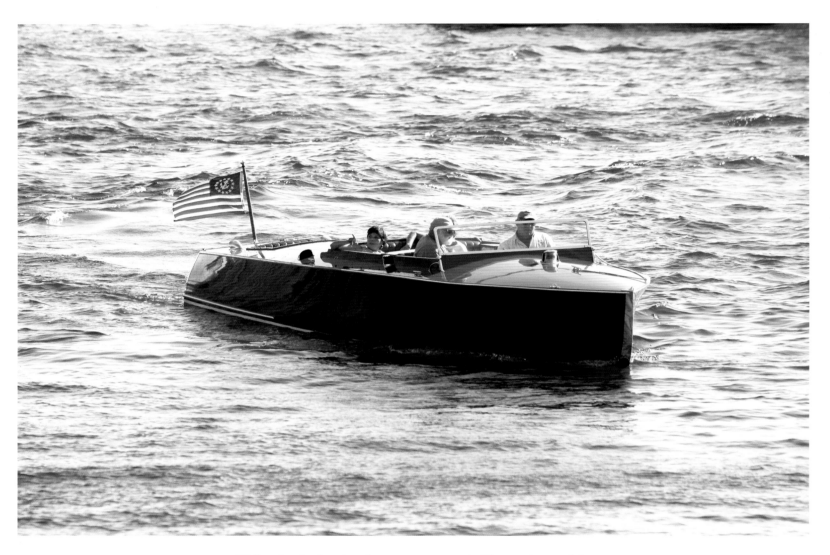

Well-maintained antique boats are common in Clayton, home of the
Antique Boat Museum, which has a priceless collection of more than 200 boats.
An antique boat show and sale is held each August.

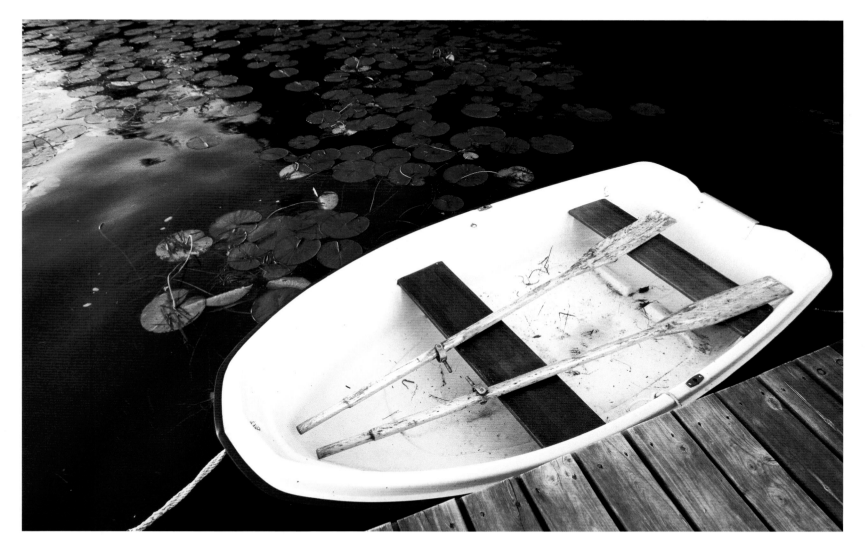

This fun and interesting boat belongs to Douglas and
Mary Ellen "Meb" Goodfellow of Lindsay Island.

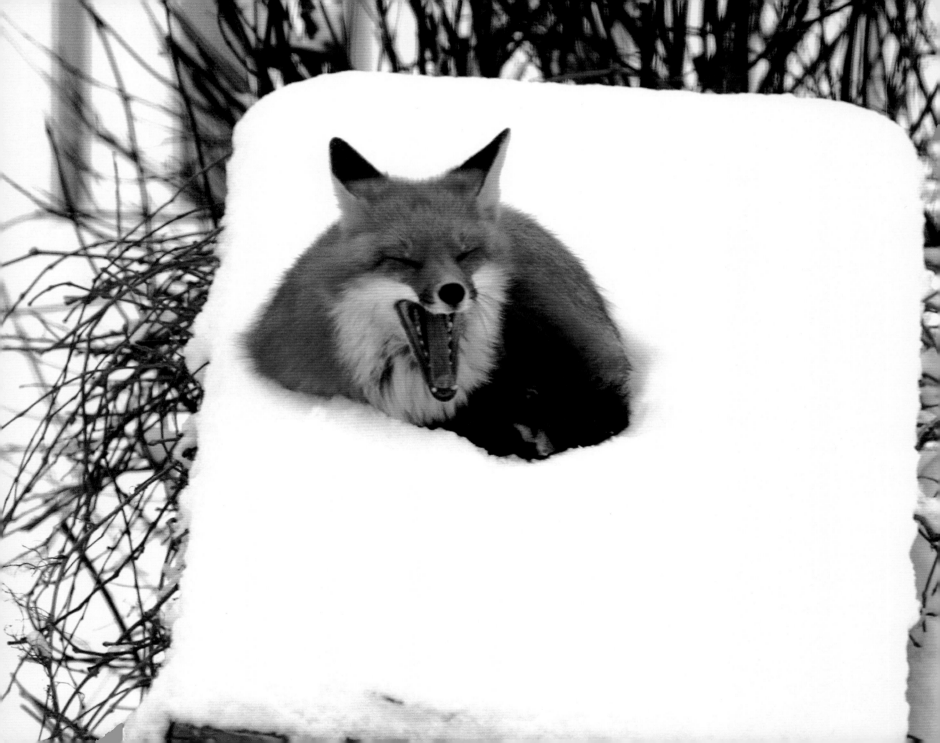

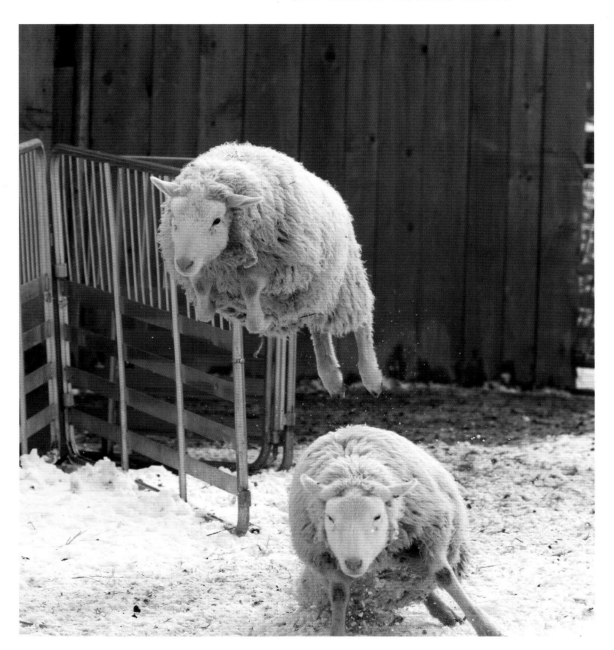

Sheep are surprisingly acrobatic, as these ones demonstrate at a farm west of Kingston.

Left: A fox makes itself comfortable on a snow-covered flower pot in the backyard of Peter and Frances Splinter.

These squirrels on Amherst Island don't need to read the sign to help themselves.

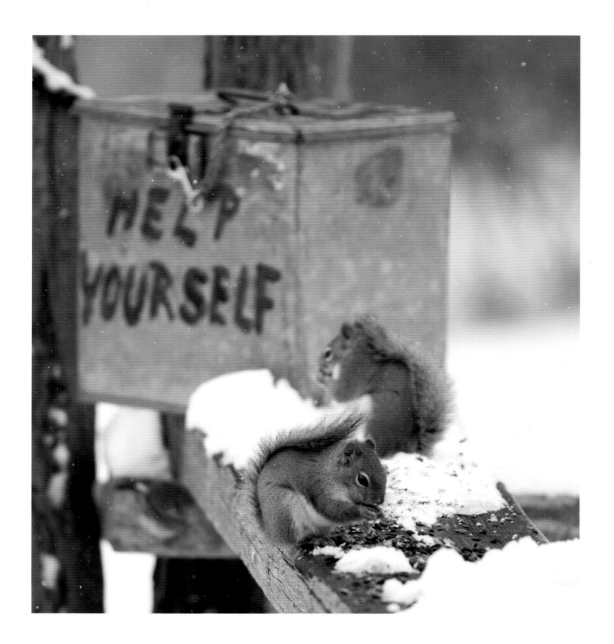

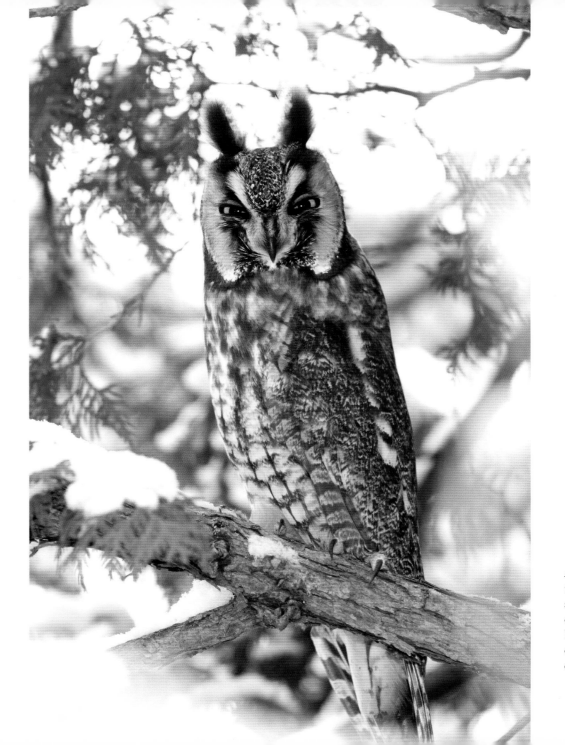

A Long-eared Owl keeps an eye on
the photographer at Amherst Island,
a birder's paradise. Various species of
owl — Great Gray, Snowy, Short-eared,
Boreal, Saw-whet and Hawk Owls —
congregate there in the winter because
of the island's large population of voles.

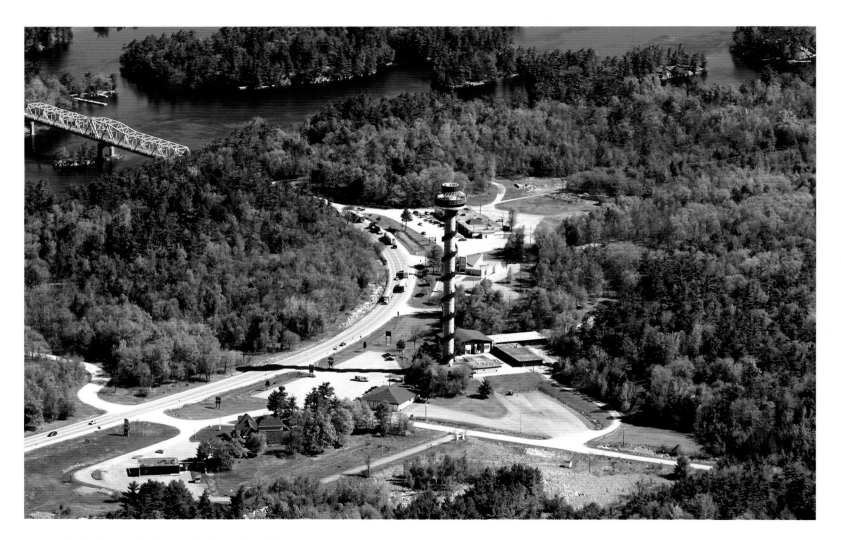

Skydeck near the Ivy Lea bridge offers visitors
spectacular views of the surrounding area.

Right: Marysville is the focal point of Wolfe Island,
the largest island in the region. It is 21 miles long
and encompasses 33,500 acres of land.

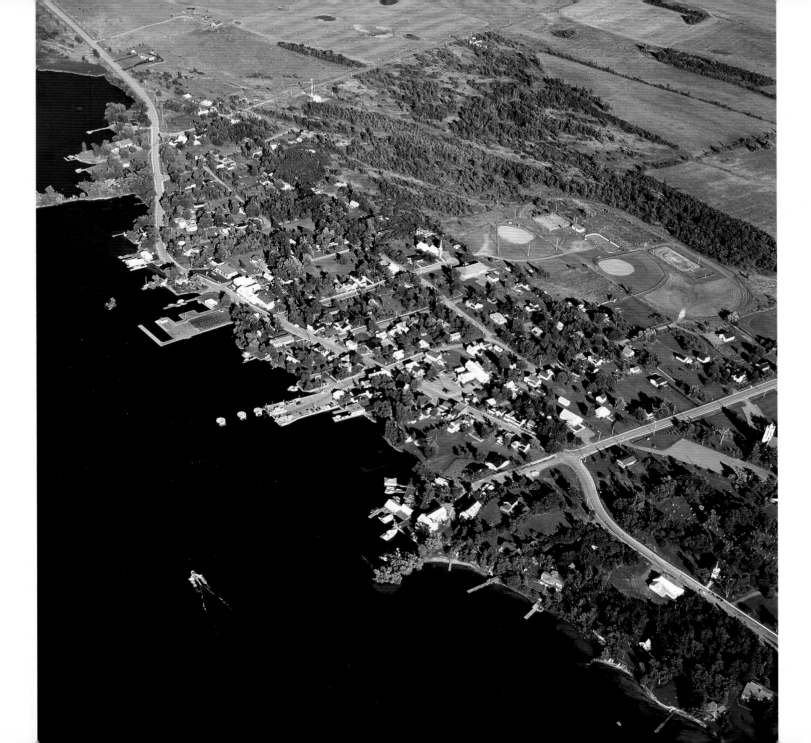

59

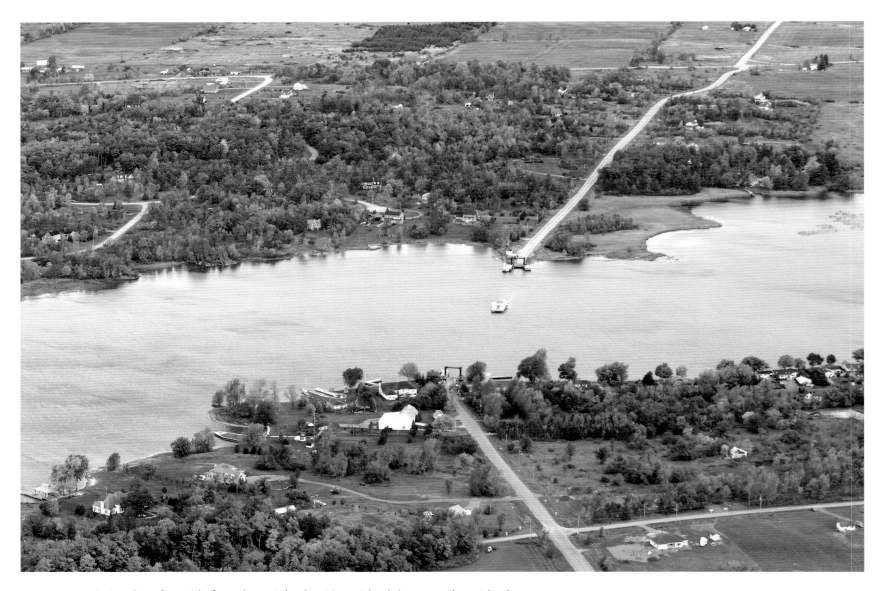

It is a short ferry ride from the mainland to Howe Island, bottom, a large island named after General William Howe, commander in chief of British forces in North America between 1776 and 1778.

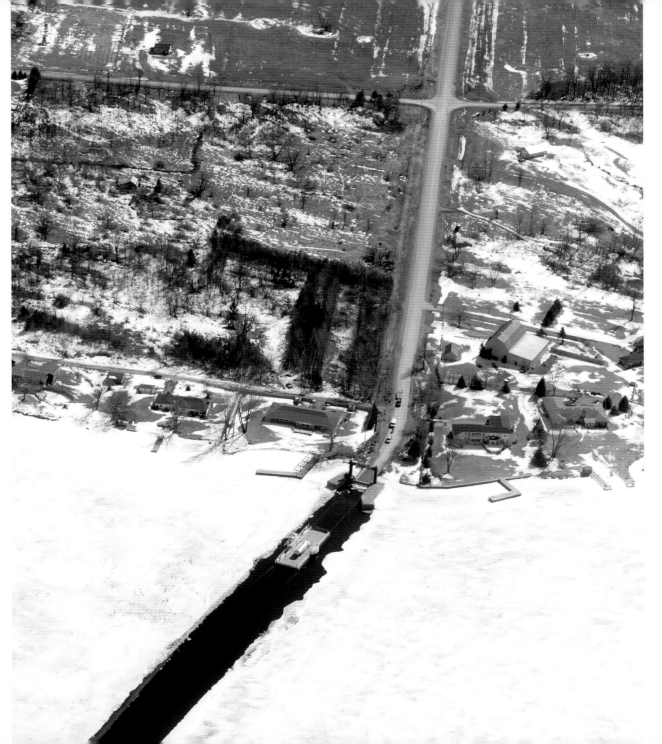

Even in the winter, a channel is kept open for the Howe Island ferry.

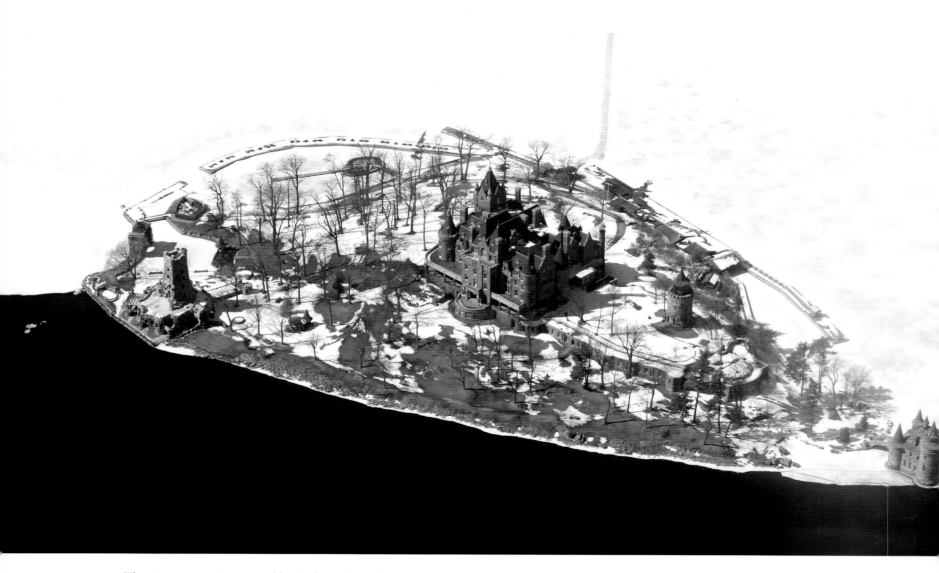

The six-storey, 120-room Boldt Castle at Alexandria Bay is an impressive sight in any season.
It features steel and concrete roofs and granite walls. Hotelier George Boldt spent $2.5 million
on it, but halted its construction when his wife Louise died in 1904.

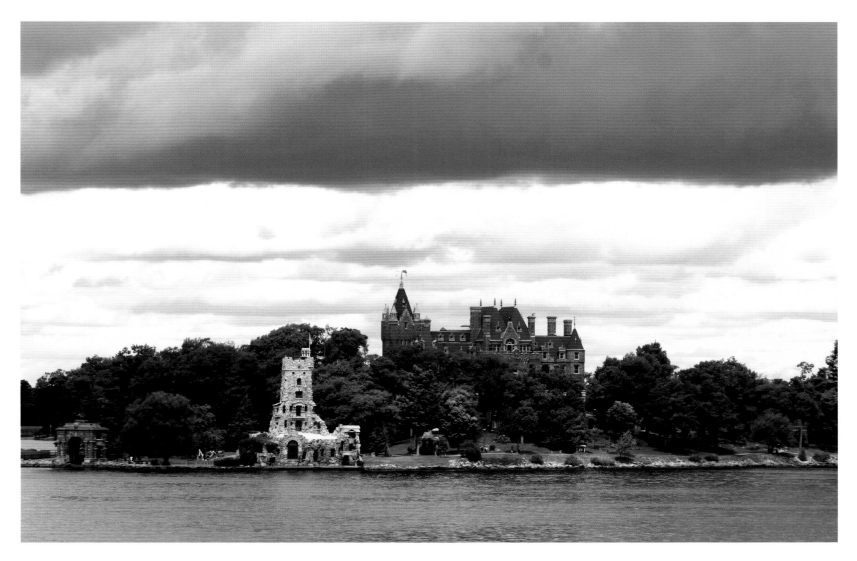

Viewed from Alexandria Bay, Boldt Castle
is an imposing structure. At left is Alster
Tower, the children's playhouse.

Boldt Castle, the region's biggest tourist attraction, sat in disrepair
for 73 years, until the Thousand Islands Bridge Authority took it
over in 1977 and began to steadily restore it.

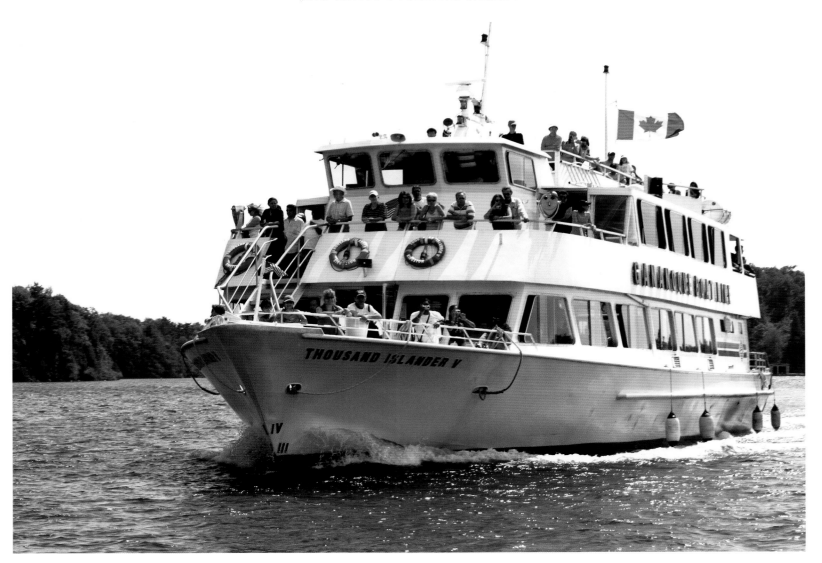

Cruise boats like this make it possible for
many tourists to enjoy the Thousand Islands.

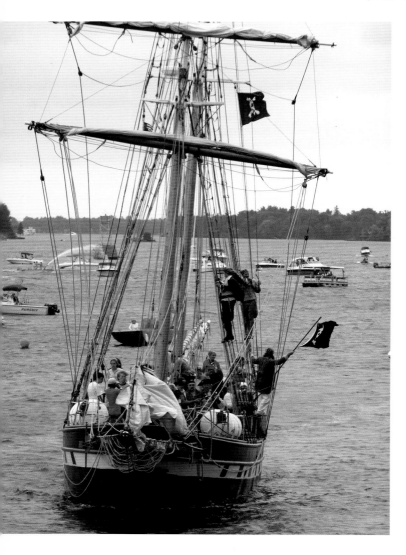

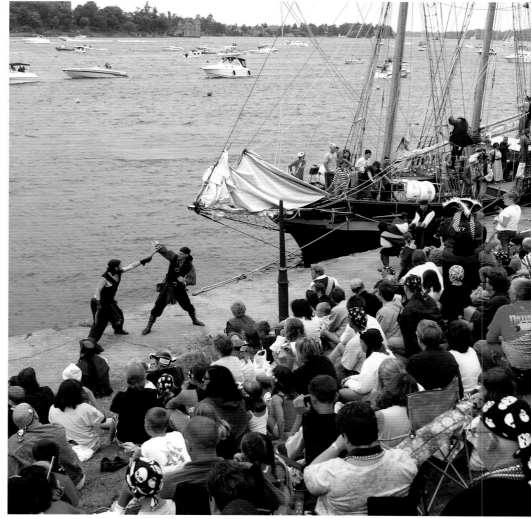

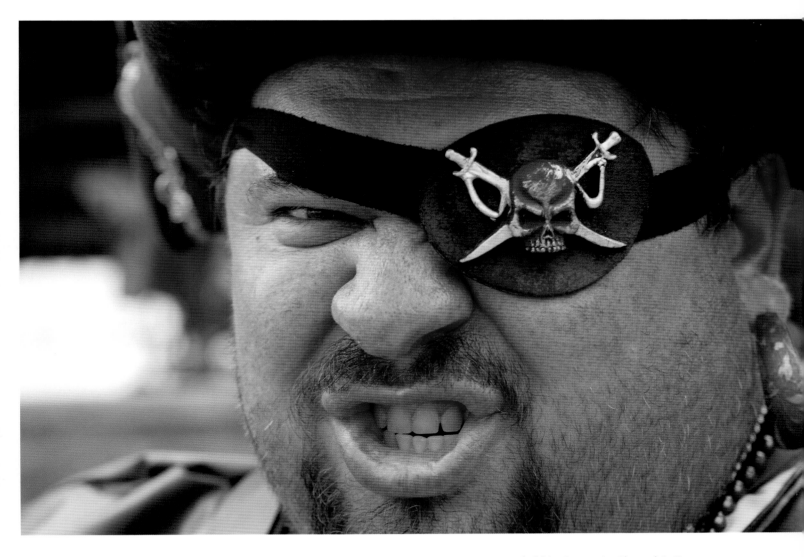

Pirate Days, held in August in Alexandria Bay, is a fun event that commemorates Alexandria Bay's famous pirate outlaw, Bill Johnston.

Historic Barriefield Village is located on the Cataraqui River, part of the Rideau Canal system.

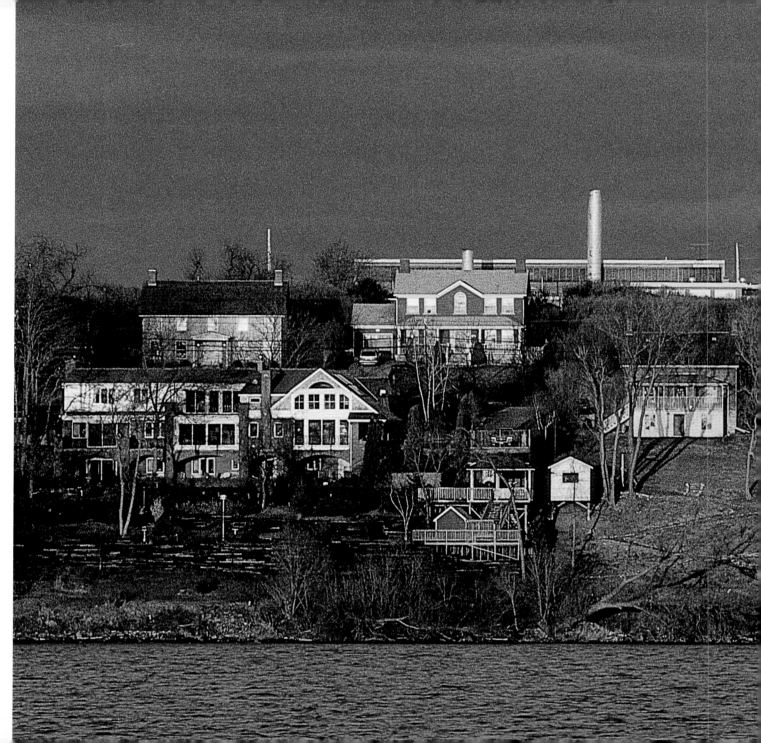

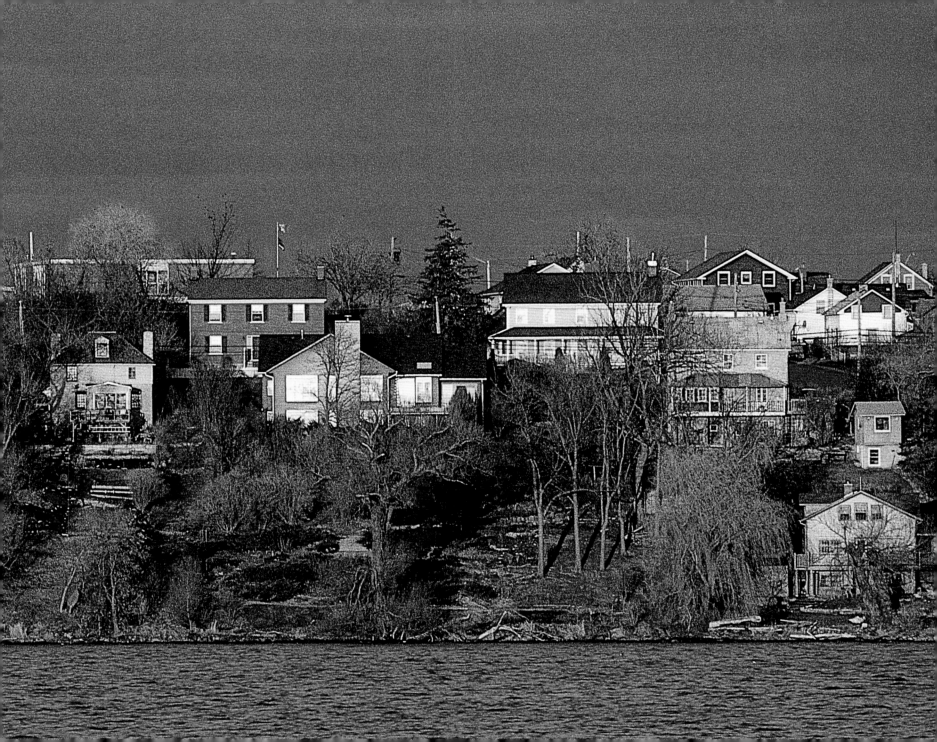

Boating is probably the most popular pastime
in the Thousand Islands.

Right: The *Cordite* is used to train cadets at the
Royal Military College of Canada.

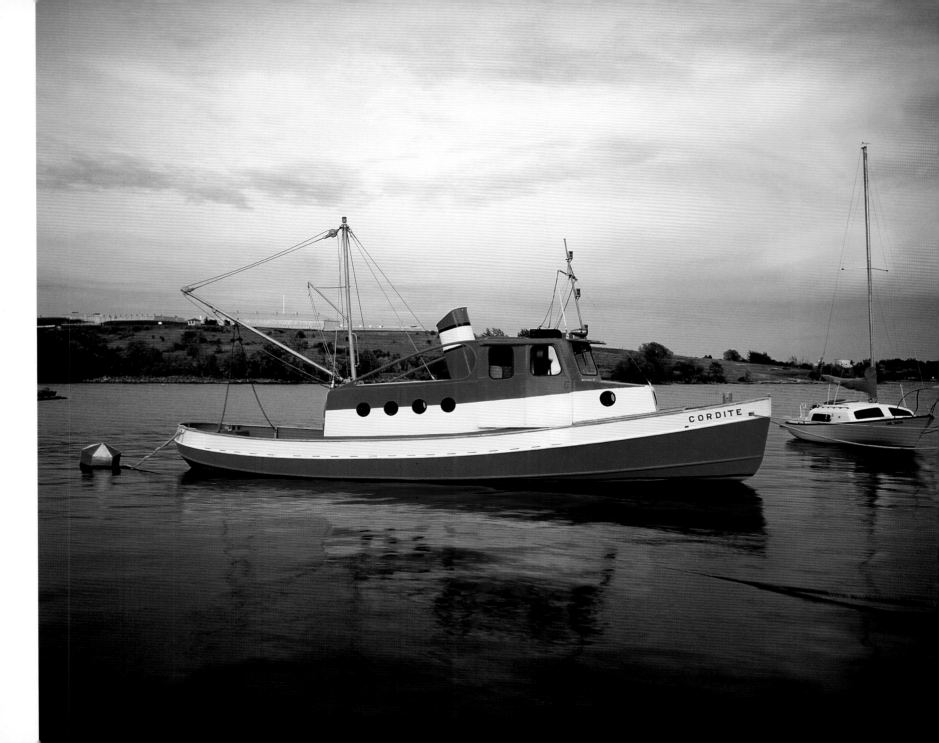

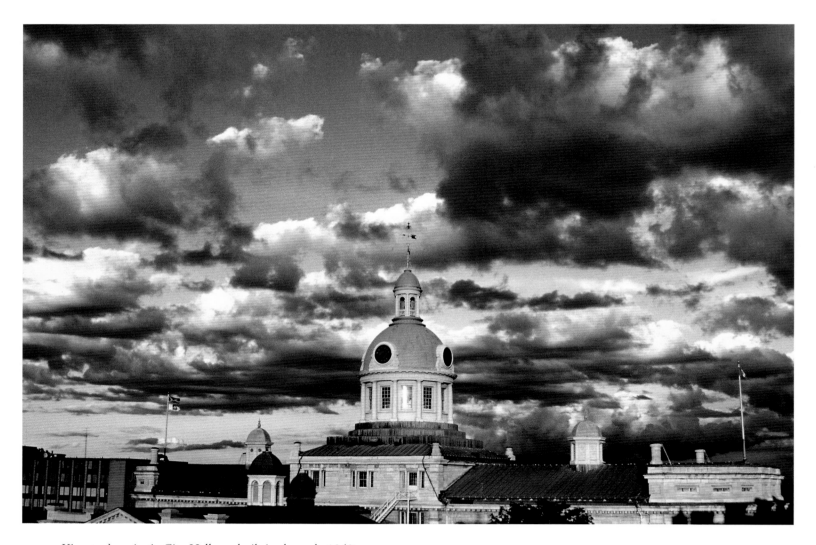

Kingston's majestic City Hall was built in the early 1840s
in a failed attempt to persuade the Powers-that-be to pre-
serve the town as the capital of Canada.

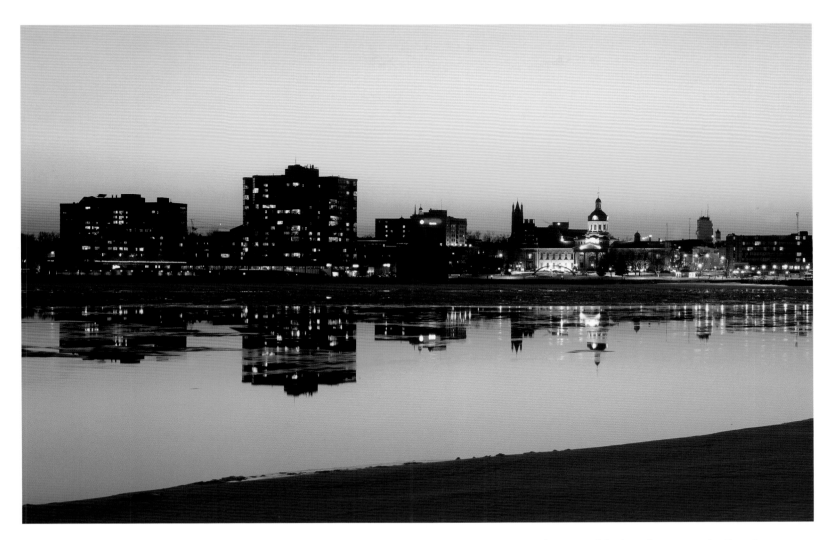

Kingston has one of the best downtowns in Ontario
and a harbour that is popular with boaters.

The Theological Hall, completed in 1880, is one of the oldest landmarks at Queen's University, which Queen Victoria established by royal charter in 1841.

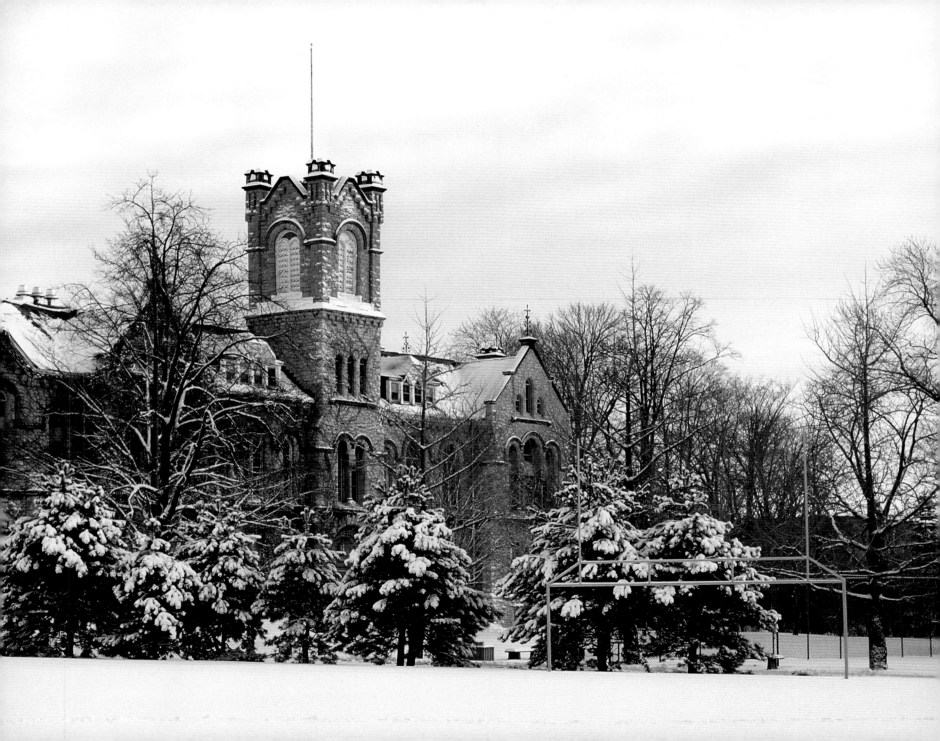

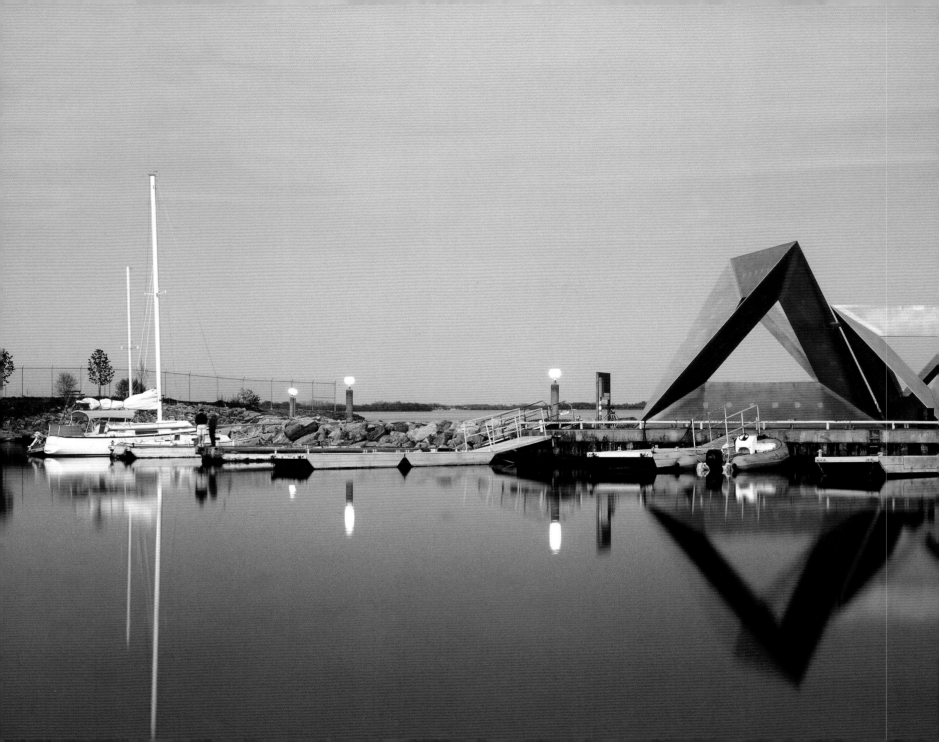

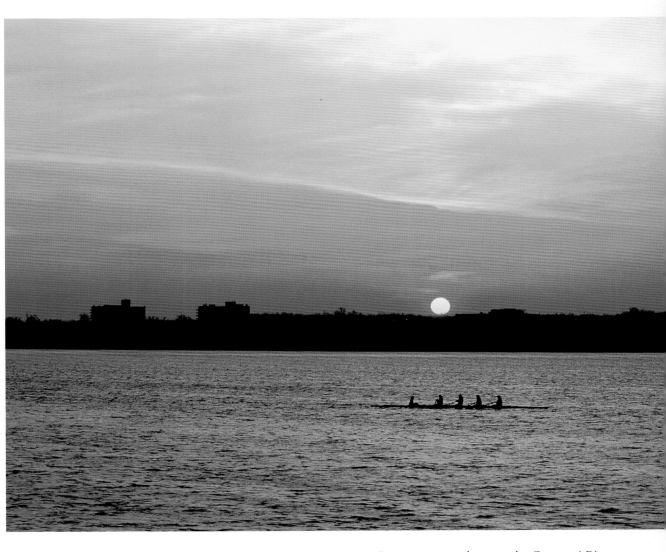

Rowers get a workout on the Cataraqui River near Barriefield.

Left: Kingston's Portsmouth Olympic Harbour was built to host the 1976 Olympic sailing events while the other Summer Games were held in Montreal.

77

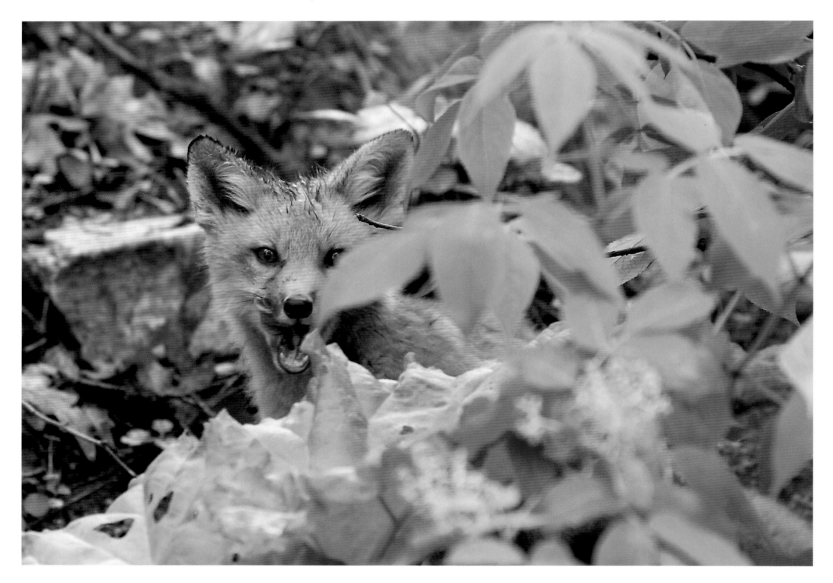

A young fox peeks out of its den on Treasure Island near Kingston.

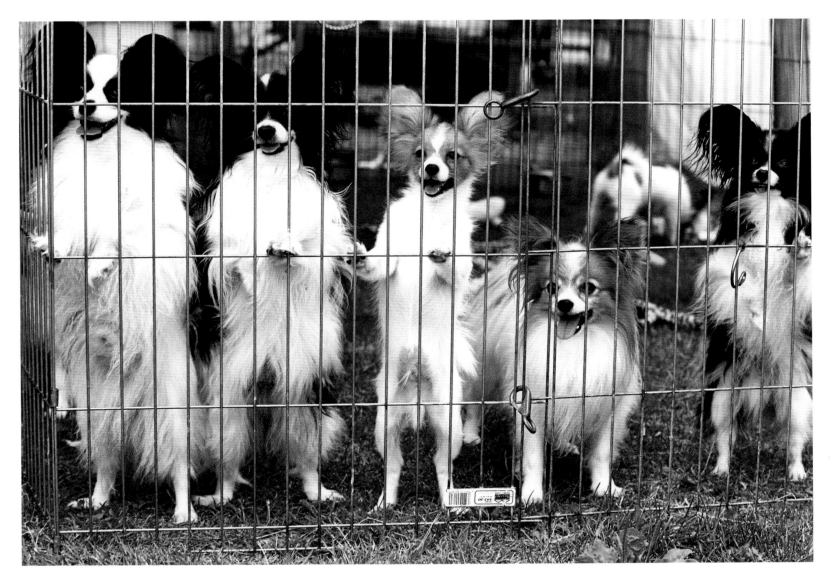

Man's best friends are on their toes during a
dog show at Lake Ontario Park in Kingston.

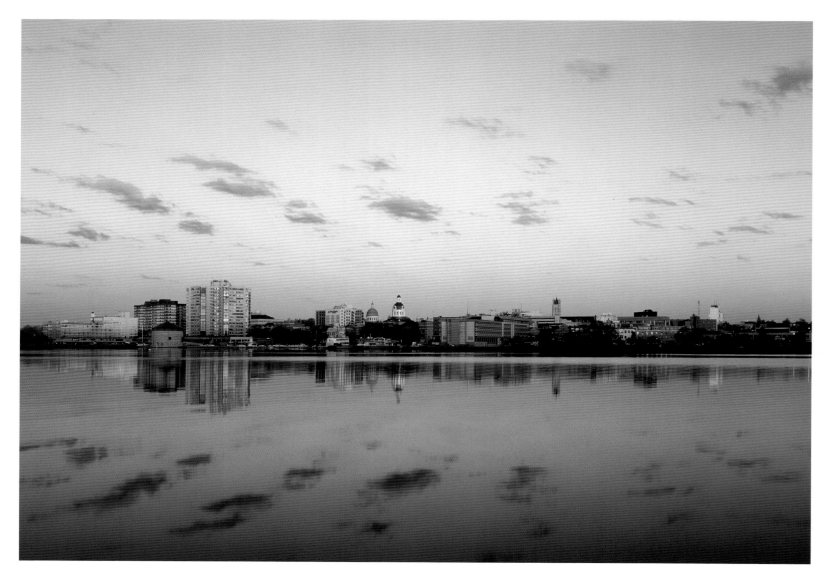

Dramatic clouds and the golden morning sun brighten up
downtown Kingston, a city with 116,000 people.

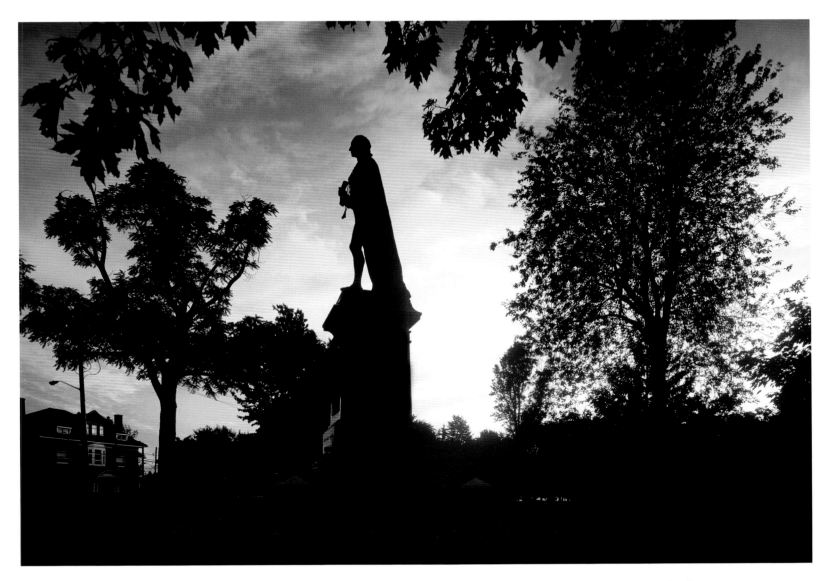

The statue of Sir John A. Macdonald, the first prime minister
of Canada, guards Kingston's City Park.

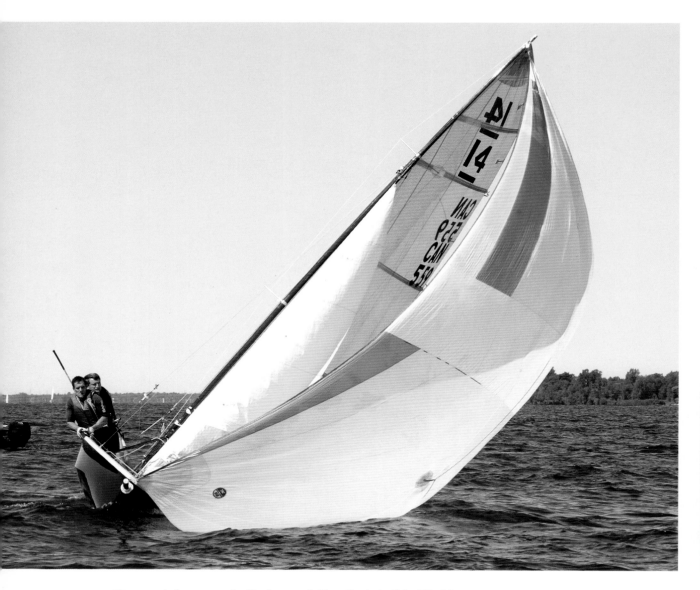

Kingston is known as the Freshwater Sailing Capital of the World.

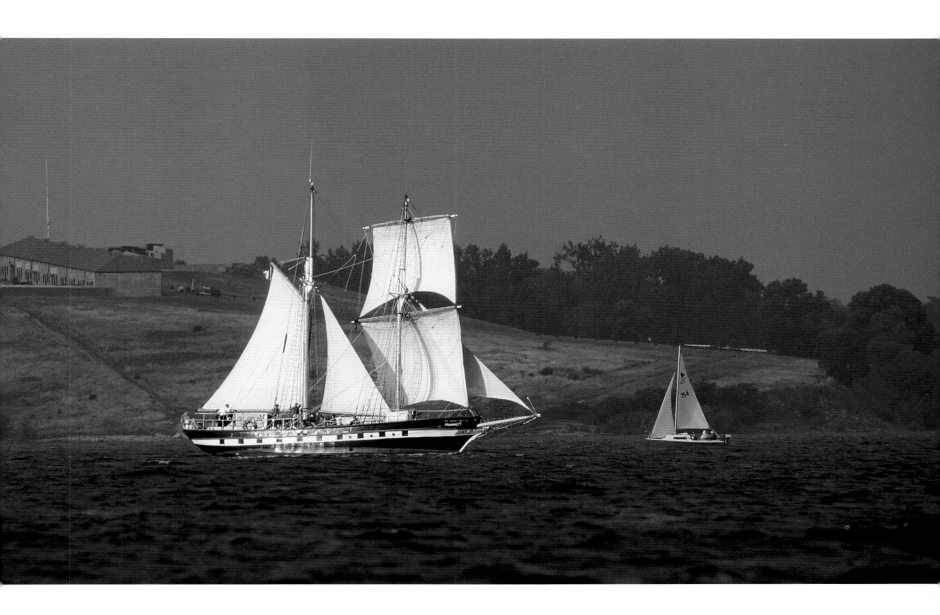

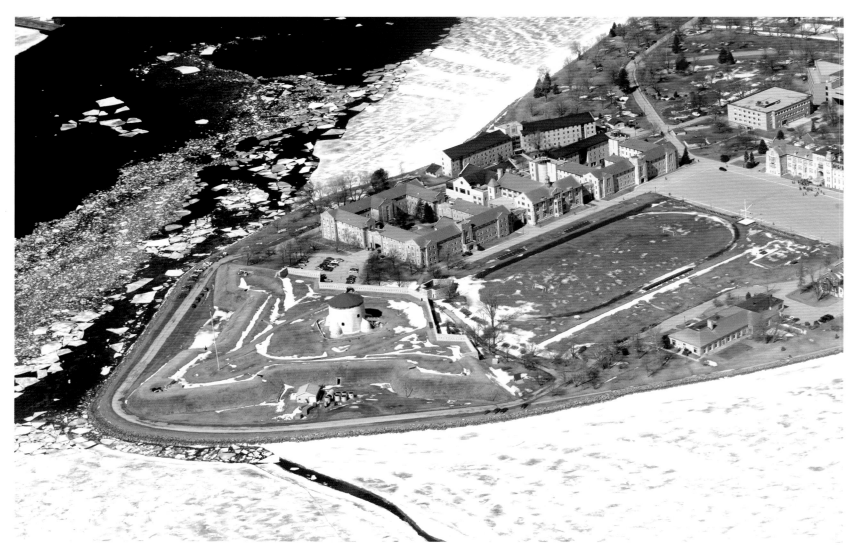

Strategically located between Kingston Harbour
(top) and Navy Bay, the Royal Military College of
Canada is the nation's only military college.

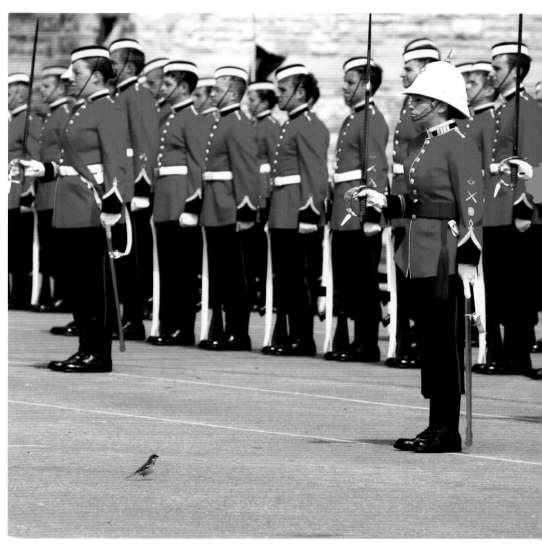

A sparrow drops by for an inspection during the graduation parade of the Royal Military College, which was founded in 1876.

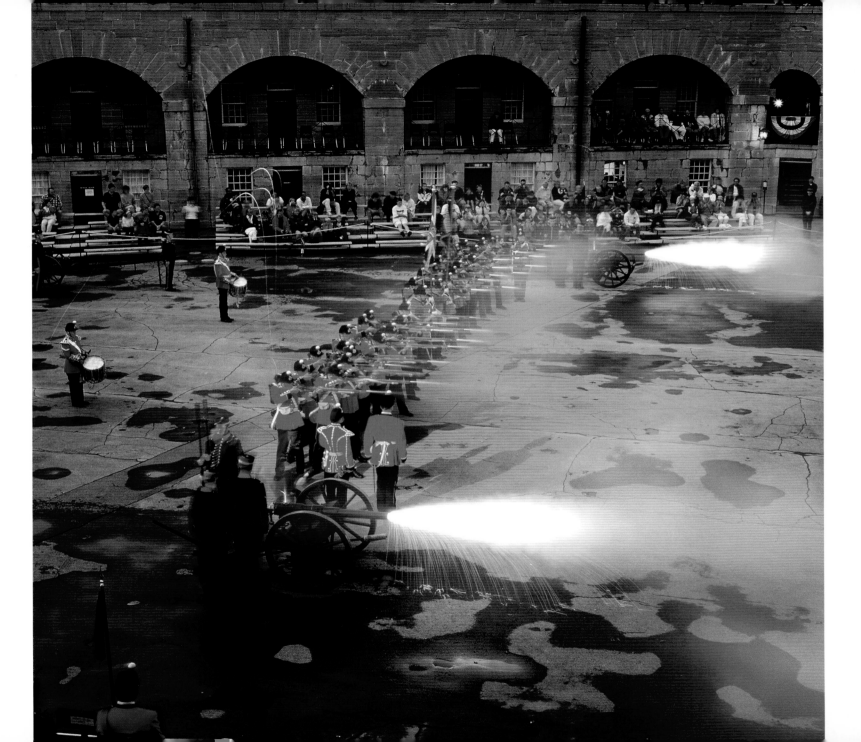

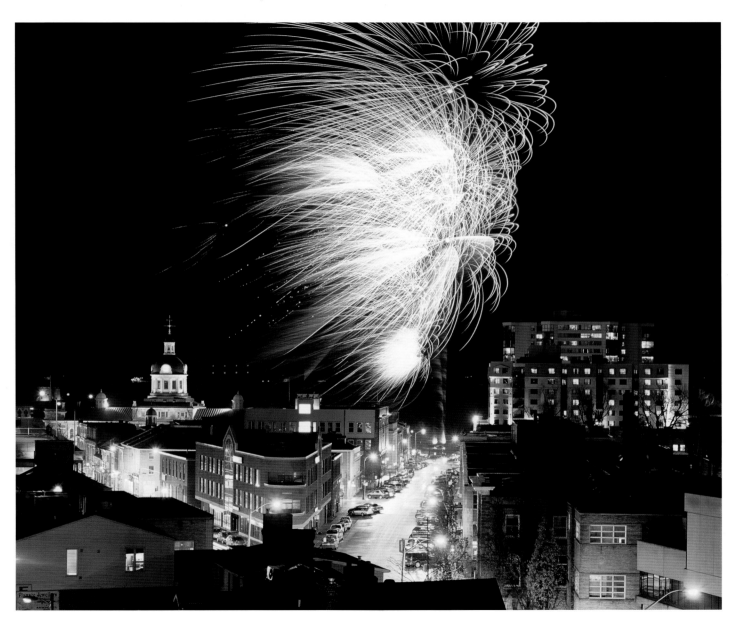

Left: Members of the Fort Henry Guard re-enact 19th-century British military precision at the Kingston fort.

The finale for Kingston's New Year's Eve is always the fireworks display over downtown.

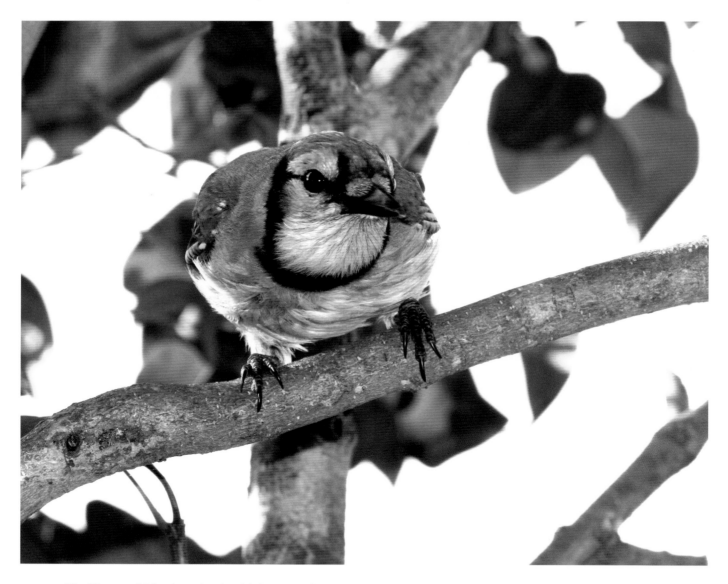

The Thousand Islands region is a birder's paradise because of the large variety of birds – from this common Blue Jay to the exotic, migratory owls.

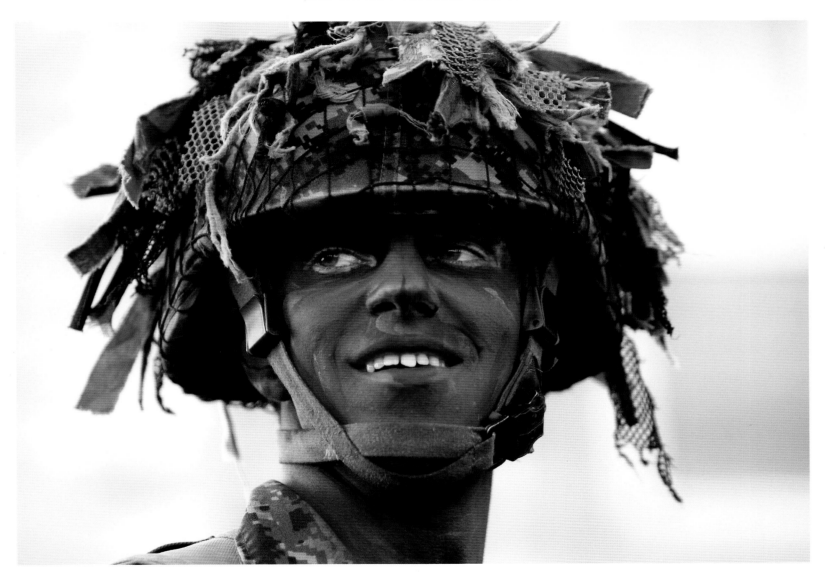

This Royal Military College cadet is camouflaged for a graduation exercise.

Kingston's annual Buskers Rendezvous attracts huge crowds.

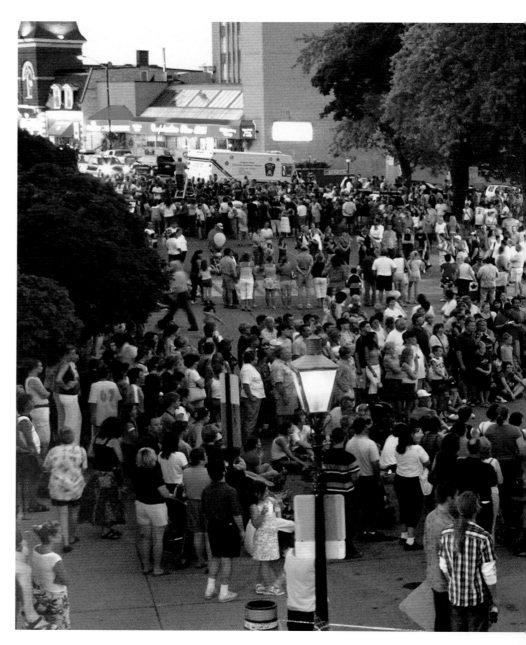

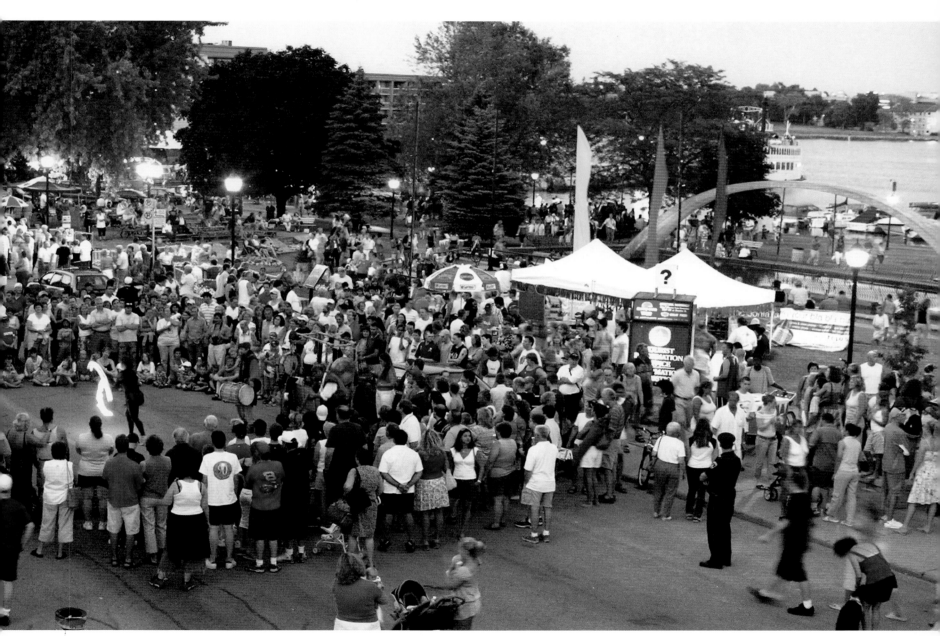

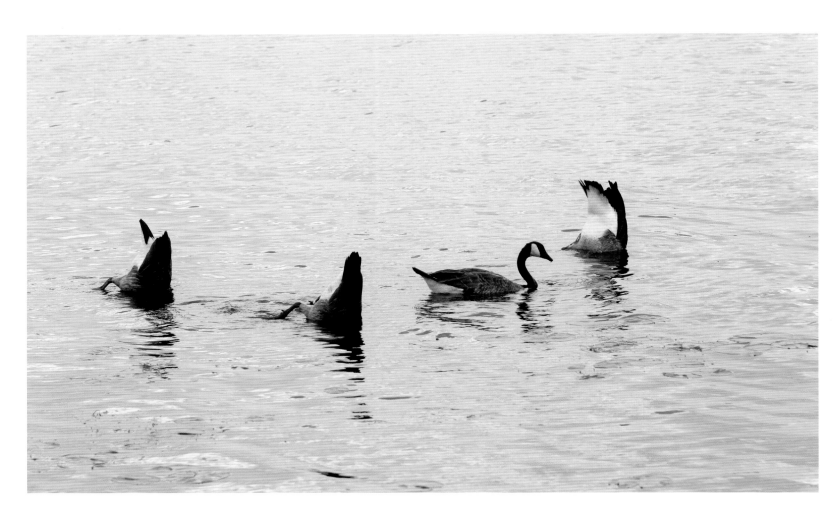

Searching for food has its ups and downs.

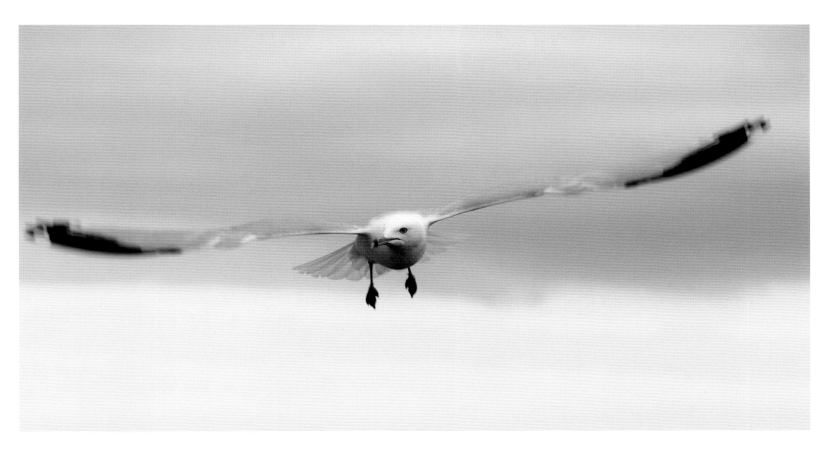

A gull spreads its wings over the Thousand Islands Parkway.

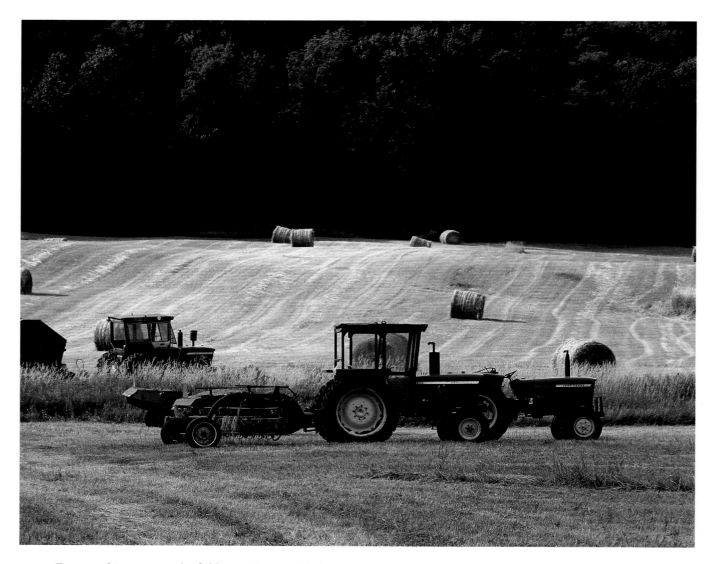

Farm machines rest on the field near Kingston Mills
after harvest season.

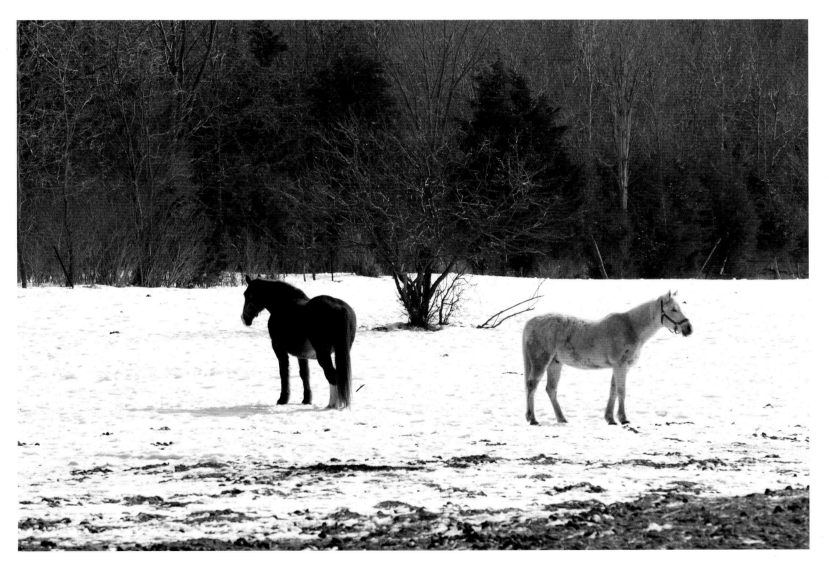

The Thousand Islands region is a good place
to see wild and domestic animals.

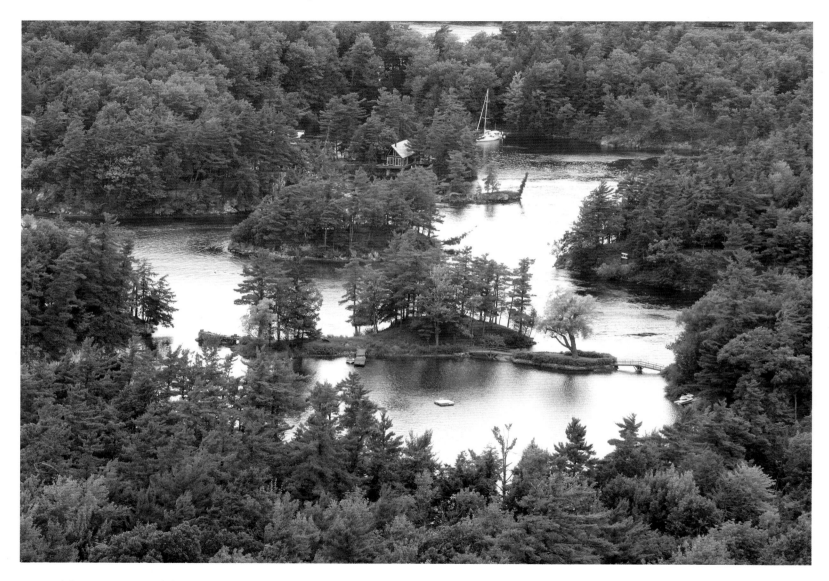

This area, as viewed from the Skydeck, is called The Lost Channel
because a British ship and its crew of 14 disappeared here in 1760.

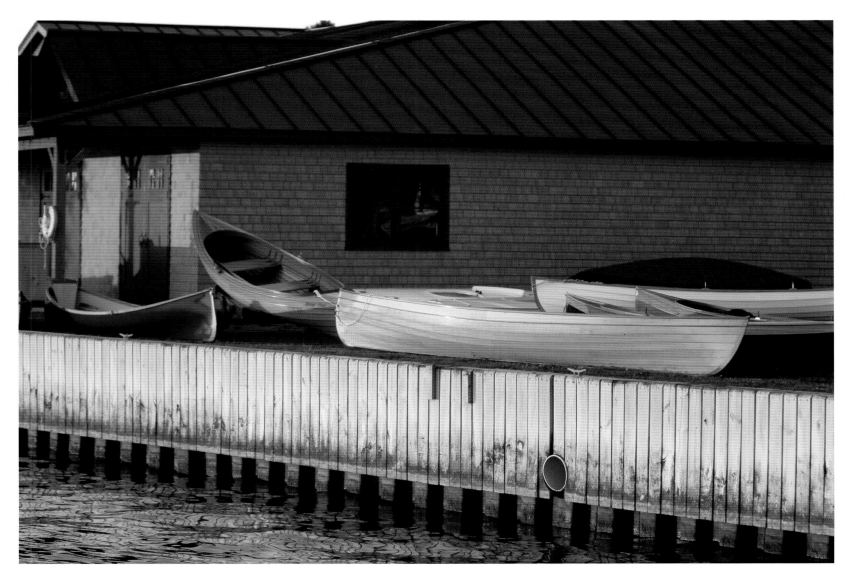

Rowboats bask in the warm glow of the setting sun over
Clayton, home of the Antique Boat Museum.

Patriotism is on display at this residence in Clayton.

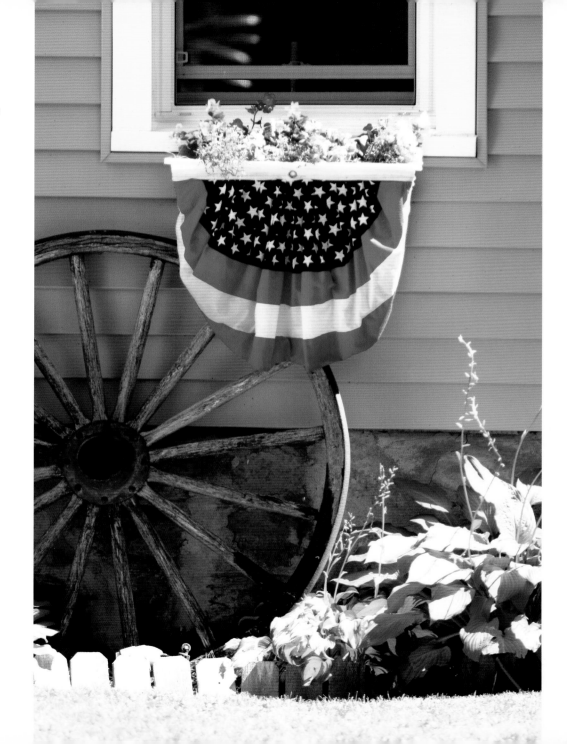

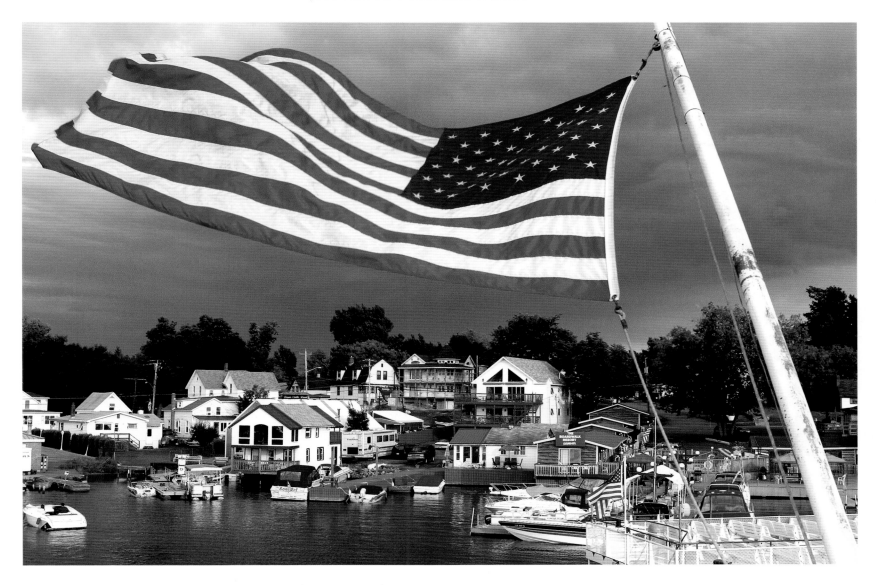

Beautiful Alexandria Bay is the main tourist destination on the
American side of the Thousand Islands.

Overleaf: Alexandria Bay, located on
the St. Lawrence Seaway, is busy with
pleasure craft and large tankers.

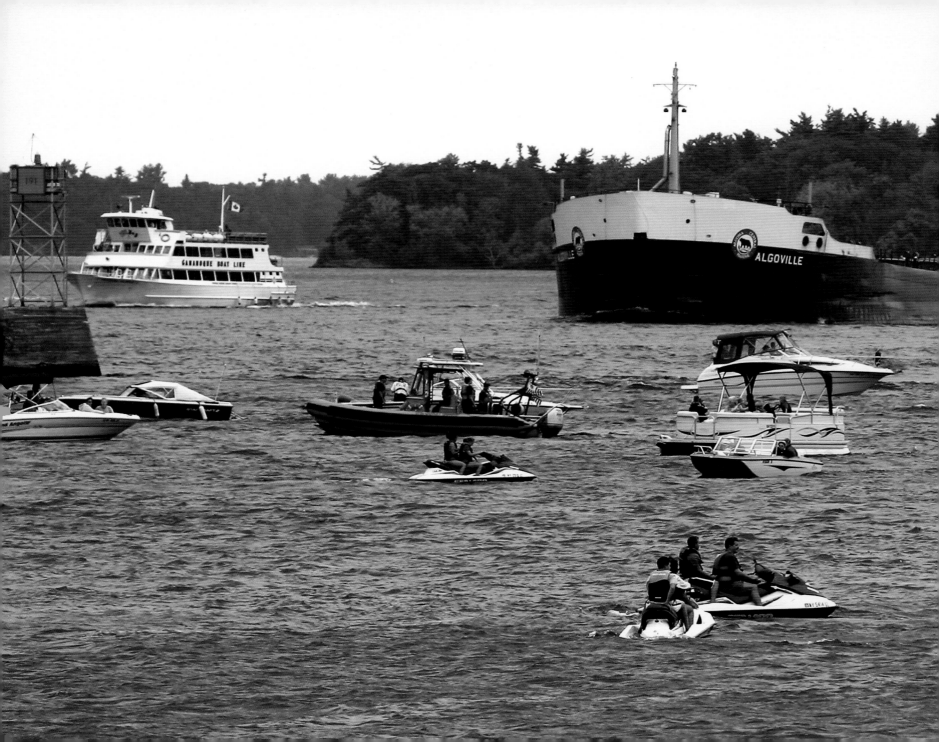

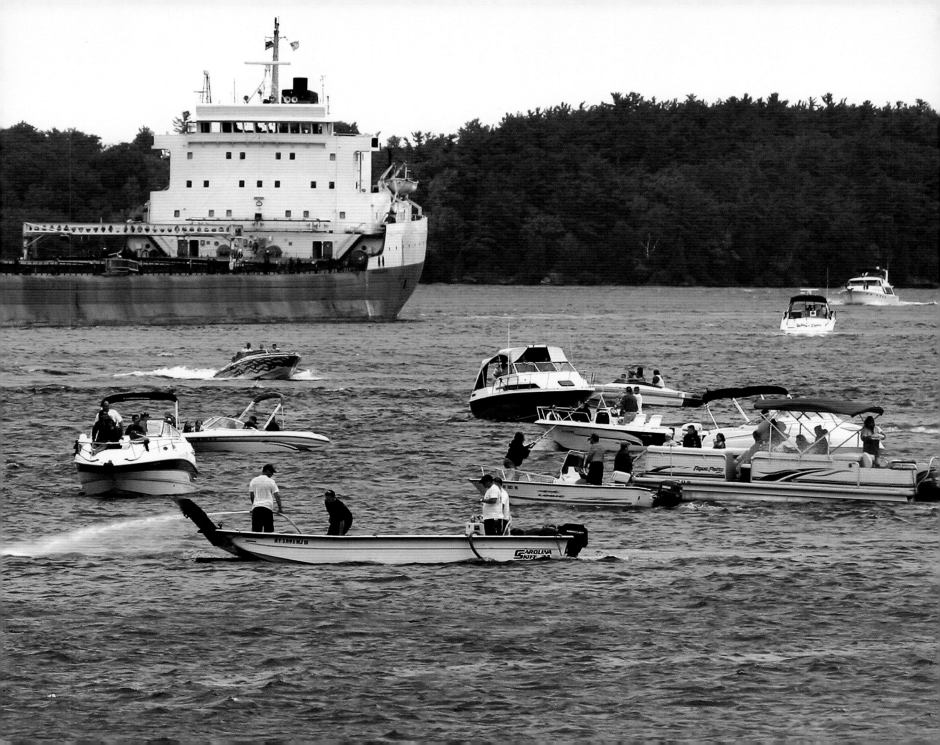

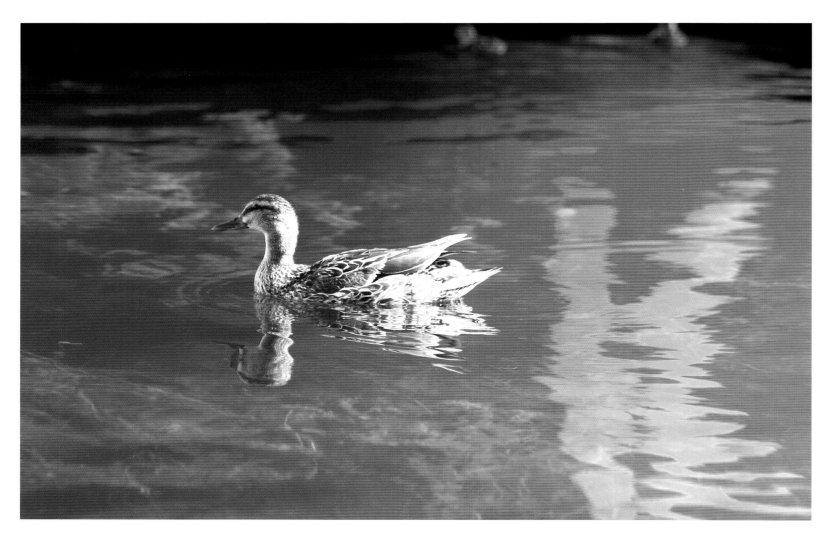

The reflection of a red boat provides the back-drop for this duck at the Kingston Yacht Club.

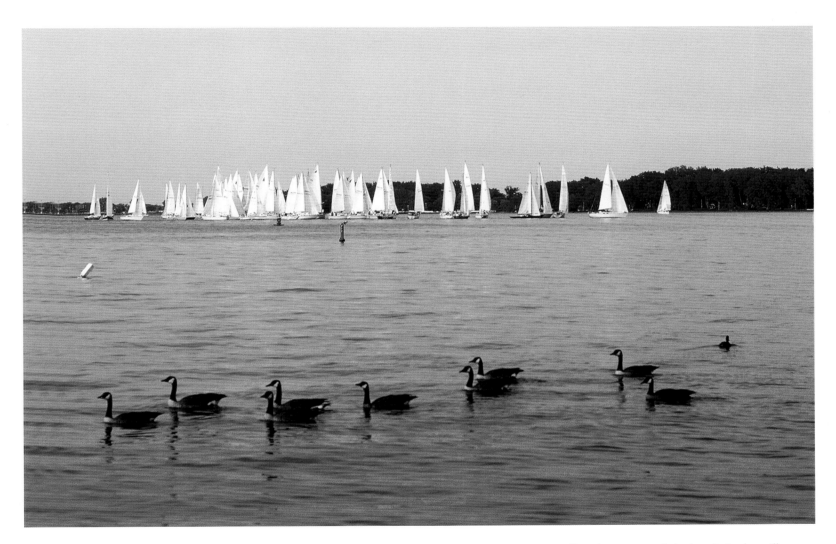

Canada geese unwittingly mimic the sailboat
formation on Lake Ontario.

Kingston can clearly be seen near the Wolfe Island ferry dock in Marysville.

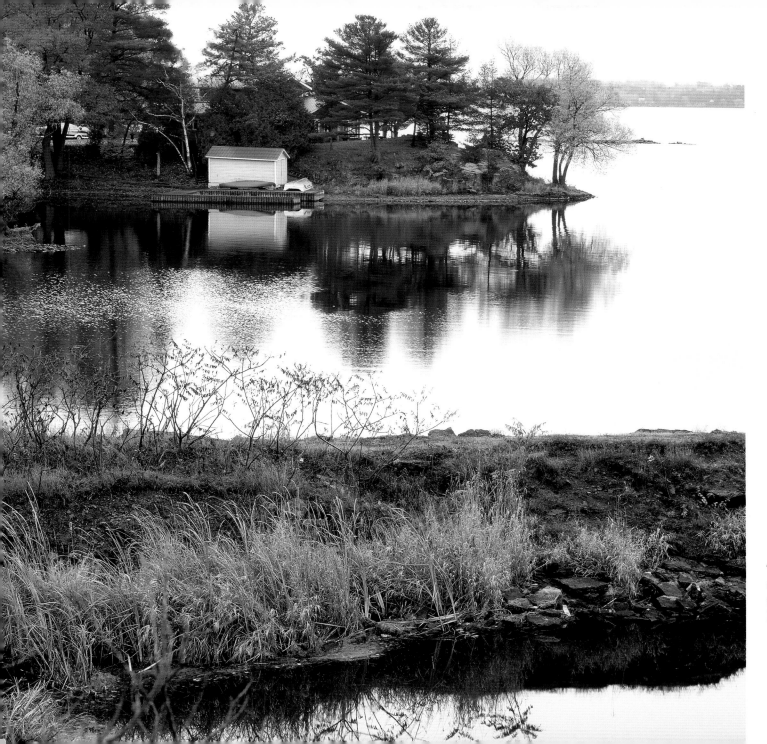

Tranquil scenes like this are common along the Thousand Islands Parkway.

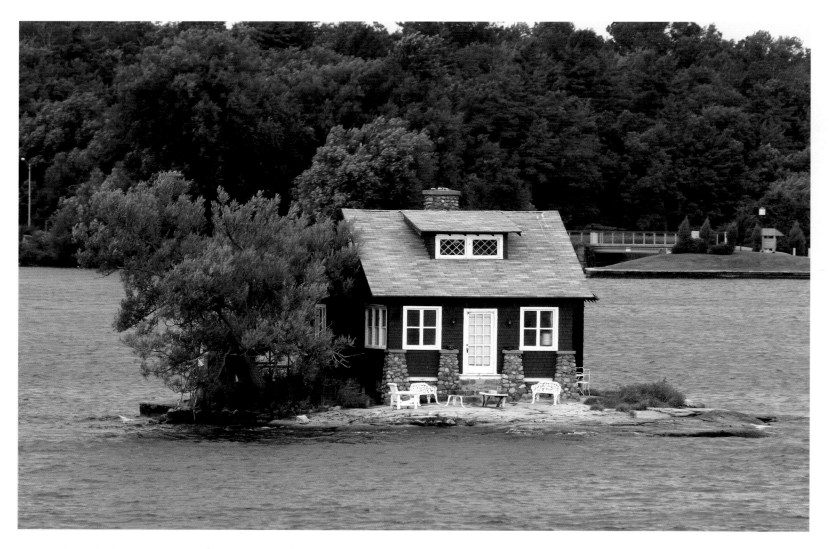

The region's cottages come in all shapes and sizes.

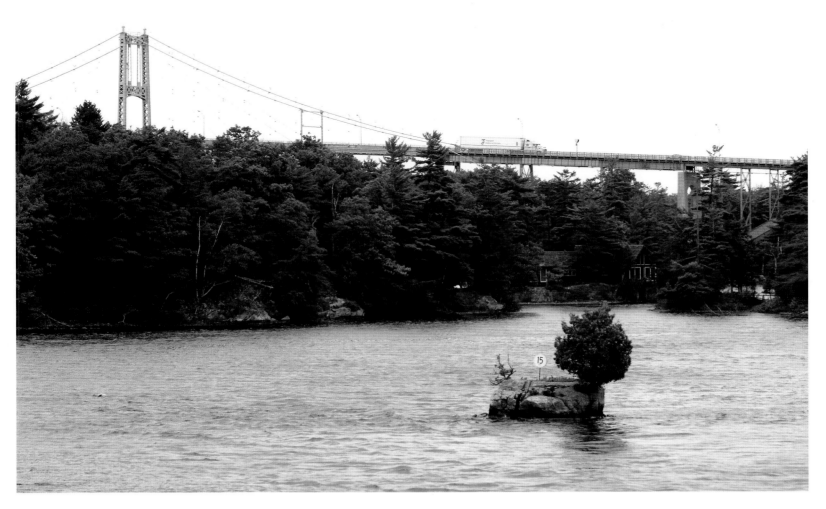

Tom Thumb, near the Thousand Islands International Bridge, is considered the smallest island. The number on the sign is for navigation.

Singer Castle was once the
summer home of Frederick Bourne,
President of the Singer Sewing
Machine Company.

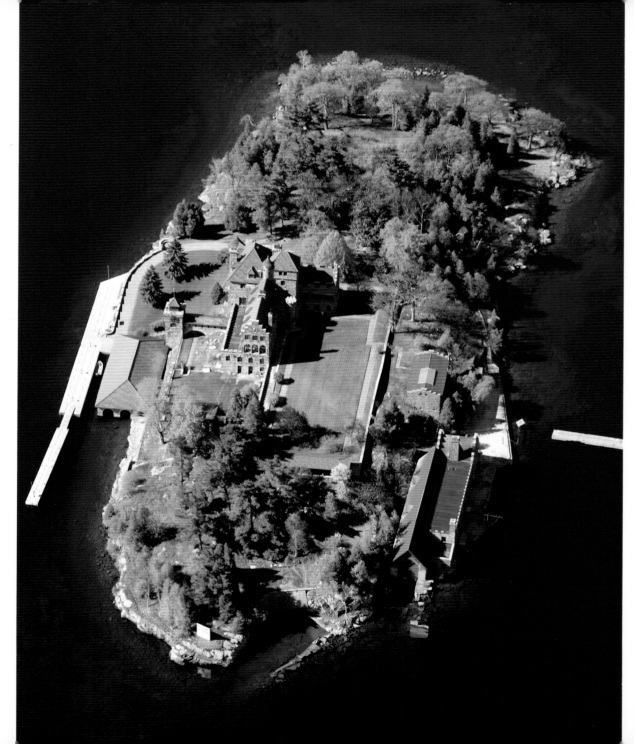

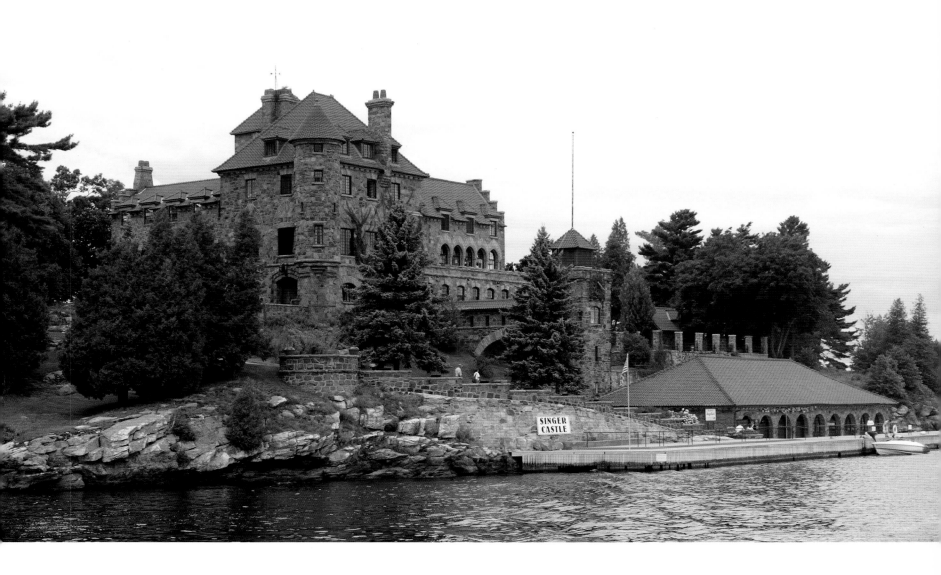

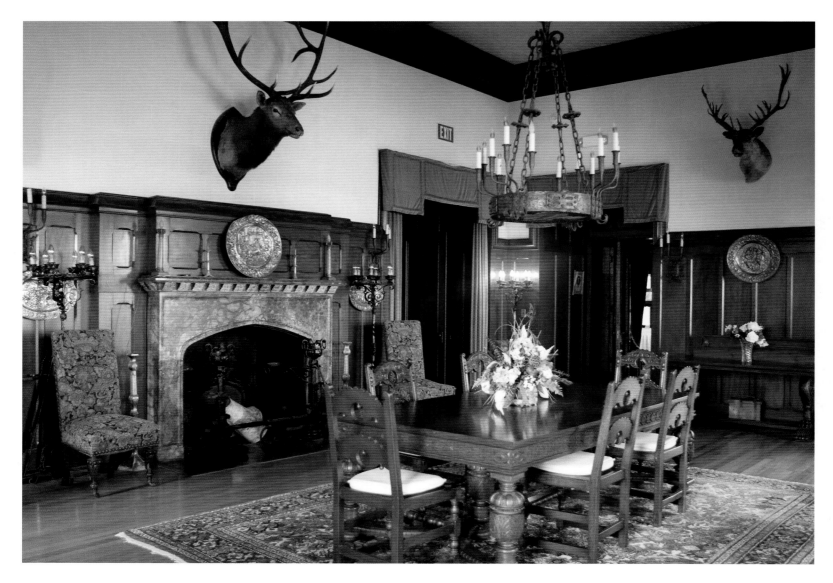

Singer Castle, now open to the public,
is a majestic structure with dungeons,
secret passageways and 28 rooms.

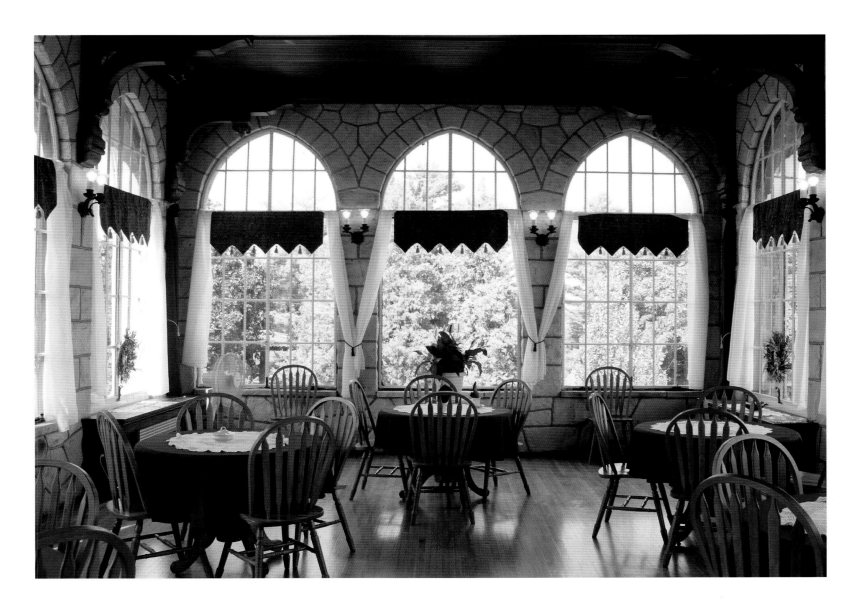

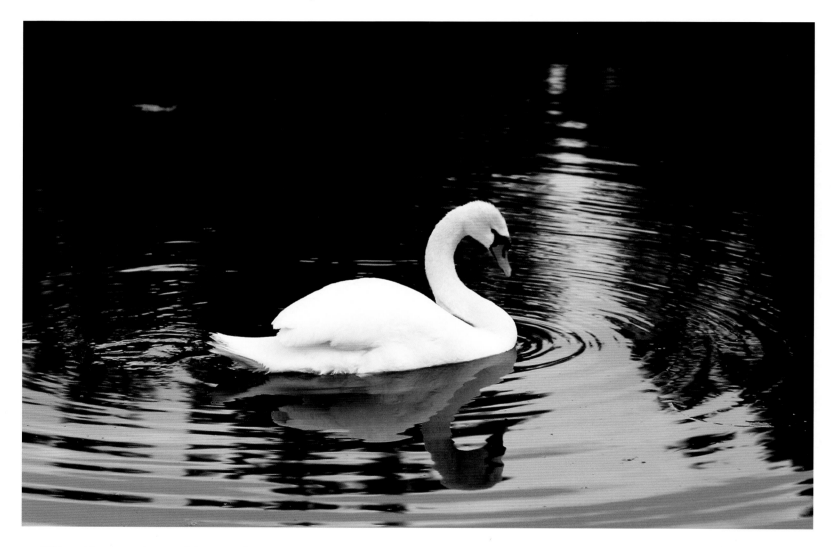

This resident swan is one of the attractions on the Gananoque River.

Right: The Thousand Islands Parkway borders the scenic St. Lawrence River between Gananoque and Brockville.

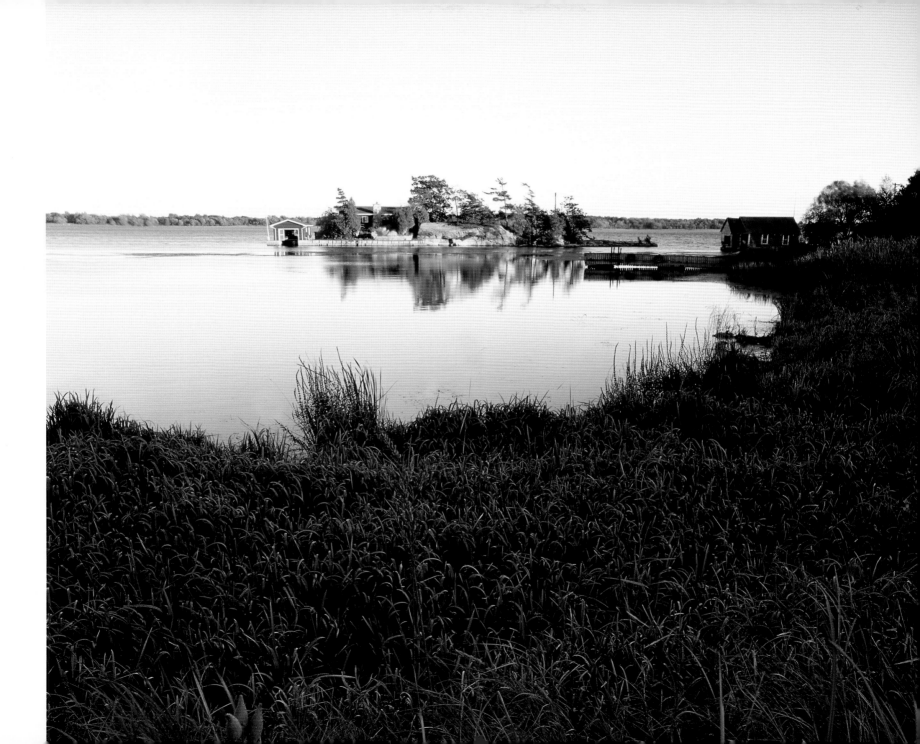

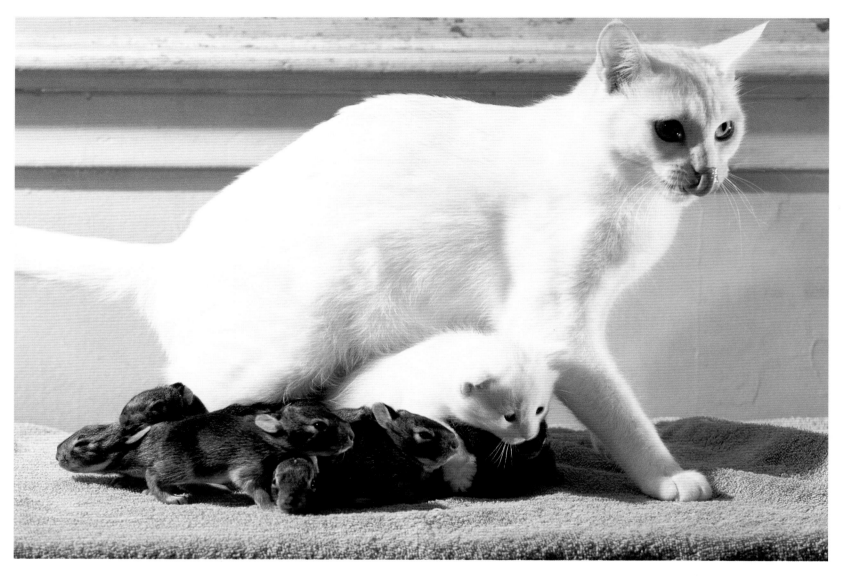

These orphaned baby rabbits are happy
to have been adopted by a caring mother.

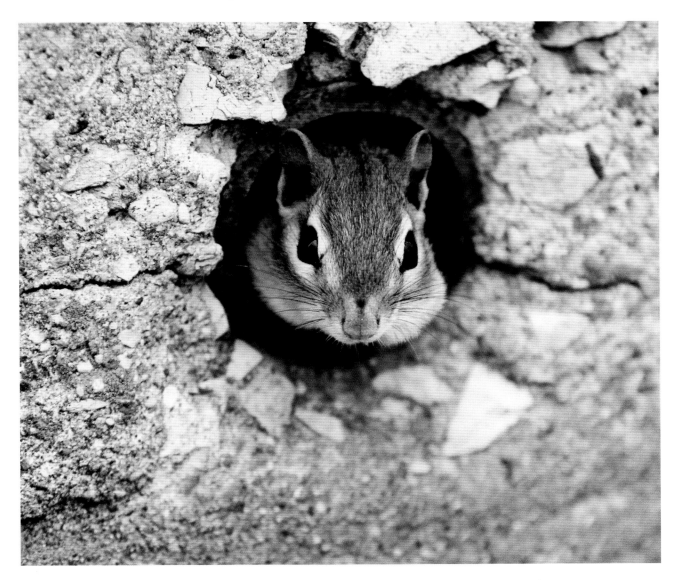

A chipmunk makes itself at home
in a chimney in Kingston.

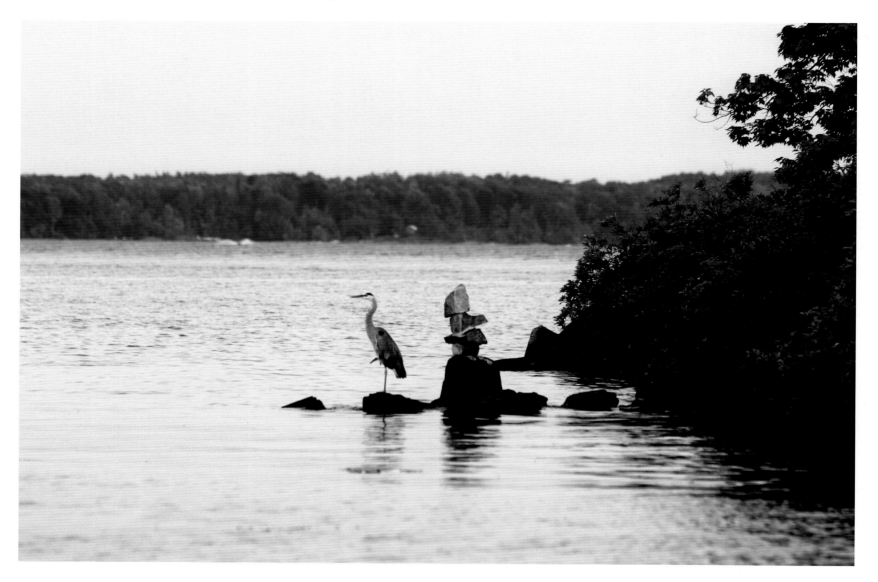

Herons are common near the marshes on both sides of the border.

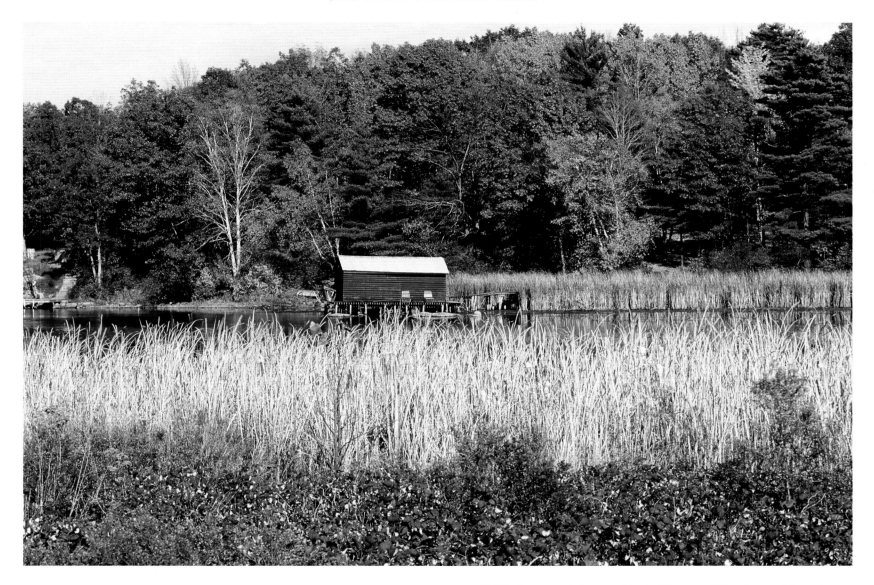

Fall is also a good time to visit the Thousand Islands, as evidenced in this scene at Grass Creek Park east of Kingston.

Two canoeists glide on the Cataraqui Creek Marshlands Conservation Area in Kingston.

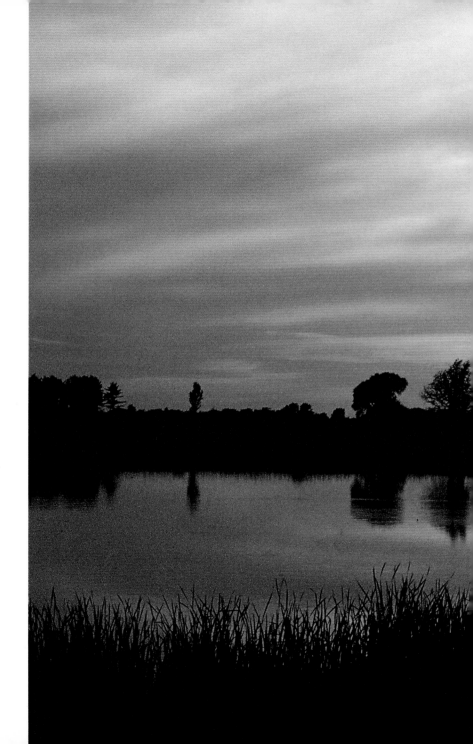

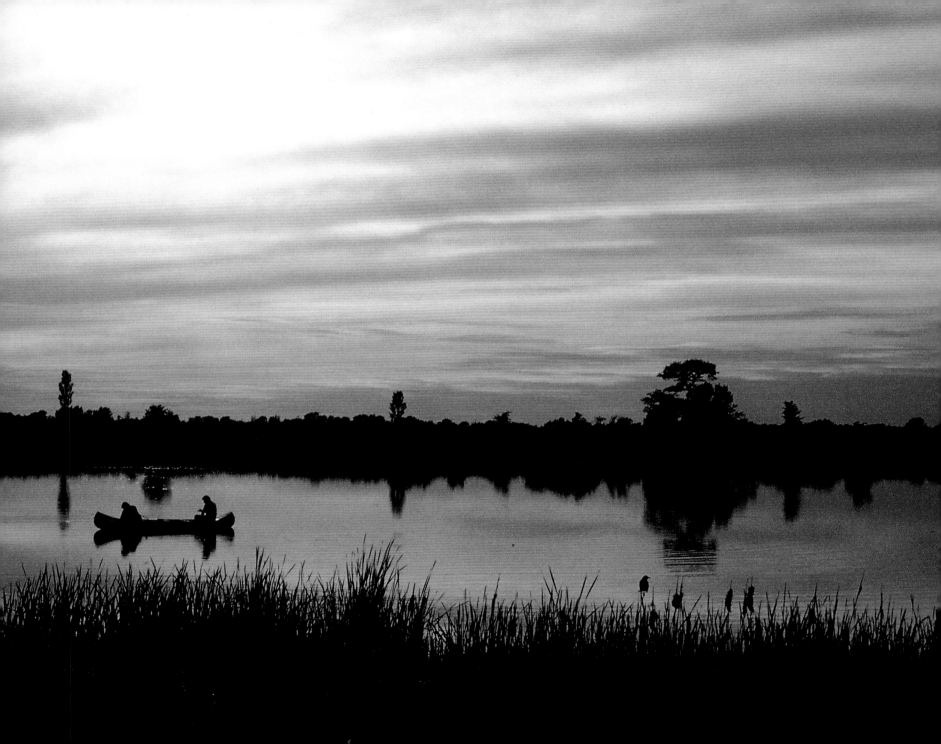

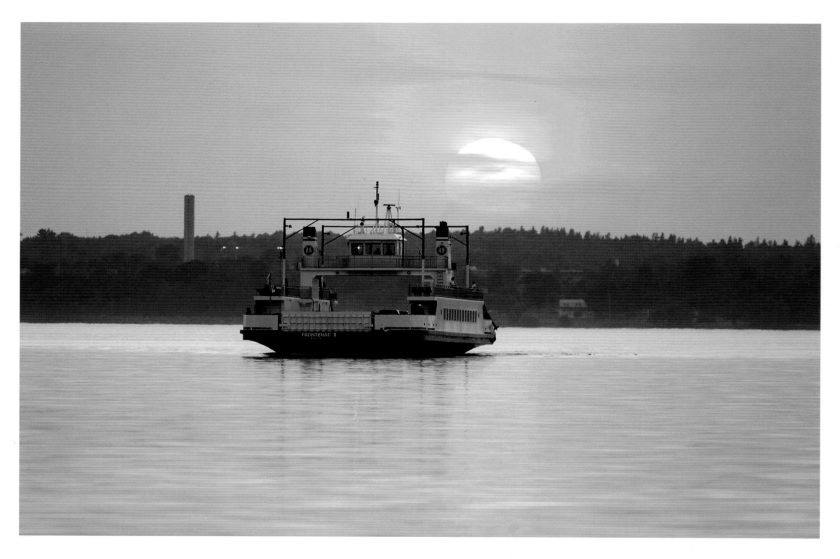

A ferry connects the mainland to Amherst Island, which is just west of Kingston. The island is not an official part of the Thousand Islands. However, many local residents consider Amherst, along with the nearby islands of Tom, Dick and Harry, part of the region.

Index

Acknowledgments

The author would like to thank the following individuals
for their help, kindness and generosity:
Keith Watson, Bernice Watson, Susan Smith, Marceli Wein, Bob
Russell, Paul Tierney, Don Ross, Sheila Mumford,
Cathy Lincoln-Chiang, Jeffrey Chiang, Christopher Chiang,
Doug and Meb Goodfellow, Merv and Nancy Earl,
Faith Avis, Janet Scott, Mike Wallace, Richard Dionne,
Darrell McCalla, Nelson Doucet,
and Amy Hingston.